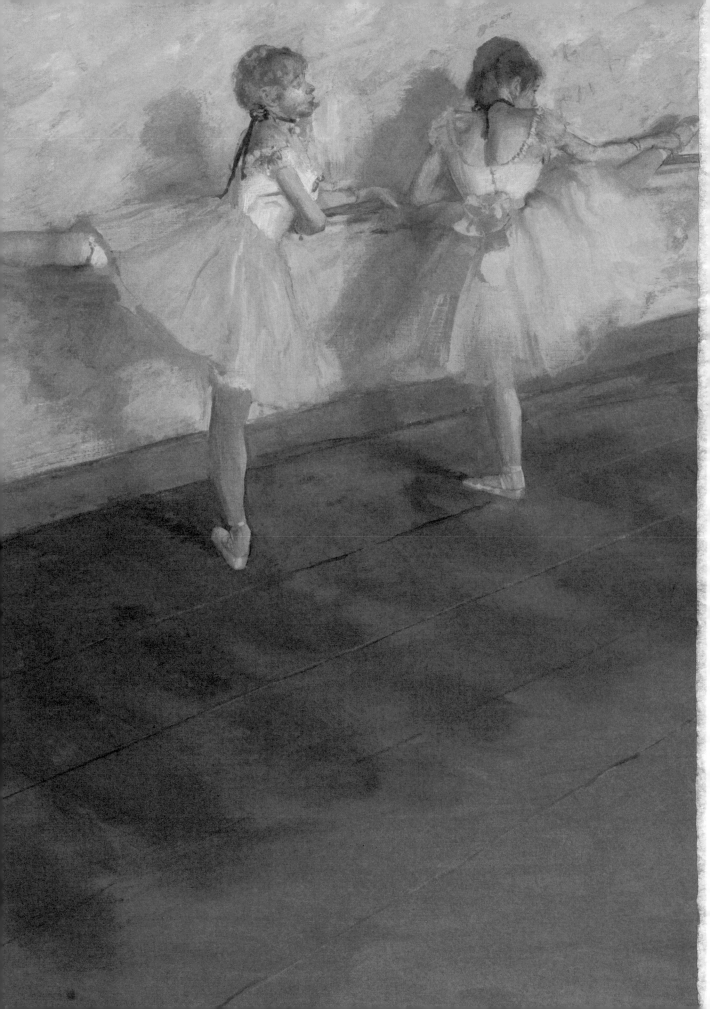

DEGAS'S DANCERS AT THE BARRE: POINT AND COUNTERPOINT

ELIZA RATHBONE

ELIZABETH STEELE

Essay by
Shelley Sturman and Daphne Barbour

Interview with
Christopher Wheeldon
by Robert Greskovic

THE PHILLIPS COLLECTION

DISTRIBUTED BY
YALE UNIVERSITY PRESS
NEW HAVEN AND LONDON

First published in the United States
of America in 2011 by
The Phillips Collection
1600 21st Street, NW
Washington, DC 20009
www.phillipscollection.org

Distributed by
Yale University Press
New Haven and London
www.yalebooks.com/art

A catalogue record for this book is available from the
Library of Congress
ISBN 978-0-300-17632-2

Published on the occasion of the exhibition
Degas's Dancers at the Barre:
Point and Counterpoint
The Phillips Collection, Washington, DC
October 1, 2011–January 8, 2012

The exhibition is organized by The Phillips Collection,
Washington, D.C.

Proudly sponsored by

LOCKHEED MARTIN

Made possible by the generous support of

Pernod Ricard
Créateurs de convivialité

Supported by a generous gift from
Perry and Euretta Rathbone

Publication produced by The Phillips Collection
Edited by Vanessa Mallory Kotz, with Vivian Djen
Designed by Skelton Design
Printed by Finlay in the U.S.A.

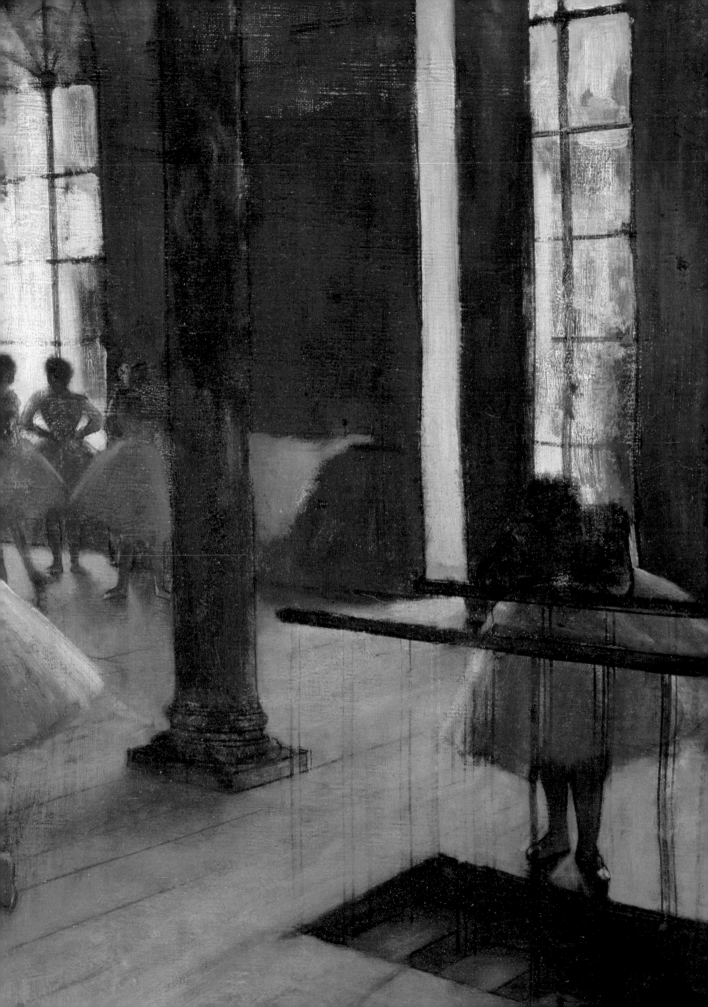

TECHNICAL NOTES

Degas's Dancers at the Barre: Point and Counterpoint spurred the interest of museum conservators to examine in depth all the works by Edgar Degas in The Phillips Collection. Each piece was studied in the conservation studio using several analytical techniques. Viewing the surfaces under a stereo microscope elucidated subtleties and details of each medium's application. Infrared reflectography and x-radiography made visible Degas's process and revisions to the compositions. The opportunity to take a closer look at the works allows conservators and curators to investigate the artist's process in a shared dialogue. The collective technical study reveals a better understanding of the complex manner in which Degas approached various media.

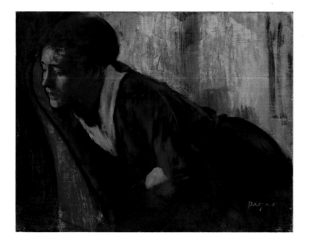

Edgar Degas
Melancholy
Late 1860s
Oil on canvas (lined)
7 1/8 x 9 7/8 in.
Acquired 1941

Degas developed the composition of *Melancholy* essentially in monochrome while building depth with translucent layers of medium-rich paint. He toned the white ground with a thin, transparent *imprimatura* of warm golden-brown, then sketched the composition using a brush and thinned black paint. Some lines of this preliminary sketch, such as the back of the chair and stripes in the upholstery pattern, can be seen in the finished painting. Infrared reflectography also reveals other details worked out at this stage, including the woman's face and hair, the outline of her figure, and the sleeves and collar of her dress.

Next, the artist applied a thin layer of dark, reddish-brown paint for the undertone of the woman's dress and the area of shadow behind the chair. In a few places, the warm tone of the *imprimatura* peeks through the brushstrokes, giving an effect of flickering light. Degas achieved deeper shadows directly behind the chair using the same paint applied more thickly and with less evidence of the brush. He created the cool diffuse light of the background using a palette knife to spread and scrape gray paint over warm undertones, exposing hints of the underlying colors and the pattern of the canvas weave.

Degas used pure color sparingly in *Melancholy,* but to maximum effect. He chose vermilion, the most vivid red available in the late 1860s, for highlights on the shoulder and torso of the seated woman, and applied a transparent glaze of the brilliant red pigment over the warm tone of the *imprimatura* to achieve the fiery glow on the back of the chair.

Bathed in light from the left, the woman's face is the focus of the composition. An infrared reflectogram (fig. 1) reveals that Degas gave considerable thought to her features, making a detailed preliminary sketch in the early stages of the picture, then significantly reworking it in the final painting. In the sketch, Degas drew the woman's hair pulled back loosely into a low braid and framed her face with short curls. In the painting, however, he swept her hairstyle into a full bouffant that reaches the top of the canvas. Formally, this change extends the sinuous line of the chair, dividing the picture and fully framing the woman's face. The infrared image also shows that originally the

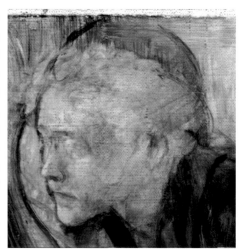

[FIG. 1]
The infrared image shows Degas's preliminary
sketch of the woman's face and hair.

woman's eyes were open and she stared ahead pensively. In the end, with a simple, skillful stroke of paint across her eye, Degas changed her expression to a downcast gaze. Although the change is subtle, it appreciably heightens the emotion of the picture.

–Patricia Favero

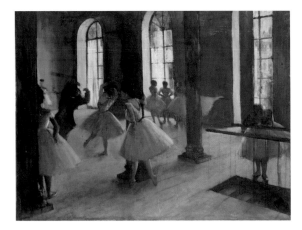

Edgar Degas
Dance Rehearsal
1873
Oil on canvas
15 $^{13}/_{16}$ x 21 $^{5}/_{16}$ in.
Acquired 2006

When conservators made an x-radiograph of *Dance Rehearsal*, they discovered a finished portrait beneath the surface (fig. 2). There is a resemblance in this hidden image to the elderly father depicted in Degas's *Father Listening to Lorenzo Pagans Playing the Guitar* from 1874, painted the year Degas's father died. Both portraits capture a man with a white mustache and heavily lidded eyes. The hidden image is possibly a middle-aged Auguste De Gas.

Close examination of the edges reveals that the canvas was cut down through the paint film on all sides except for the top, which retains some of the original tacking margin. Greenish-blue and black paint found along the edges of *Dance Rehearsal* does not relate to this interior scene, but to the portrait that lies below. Degas apparently had the painting cut down from a larger format and lined onto a second canvas. The ballet scene was then painted on top of the portrait at a later date.

Degas constructed *Dance Rehearsal* on top of a thin brown layer of paint, which is visible where it remains unpainted, as on the base of the column to the far right. He established the contours of the figures and details of the studio using a fine-haired brush dipped in black paint. Degas used a straight edge to make most of the lines that delineate the floorboards, stair railing, and other architec-

tural elements of the room. Although in a few instances, such as the window on the far right, he worked freehand. As he built up the composition using color, the artist left many of the dark lines unpainted.

Uncharacteristically, the multiple revisions of the figures and the familiar space they inhabit are not found in this picture. An infrared reflectogram shows that Degas made only a few changes to this composition. The position of the right leg of the dancer holding onto the column is shifted forward, and there are vague indications that he repositioned the left leg of the dancer taking instruction from the master. Some of the mullions in the windows are painted over, perhaps to enhance the impression of light flowing into the dance studio.

While there are no major modifications to the composition, there are signs that he did slightly rework the painting in places. Surface abrasion where Degas scraped paint away is visible in the passage containing the three dancers in the center background. Afterward, he partially repainted these figures, leaving only the barest suggestion of a head for the dancer on the right, most of it having been removed in his editing process. The flesh tones

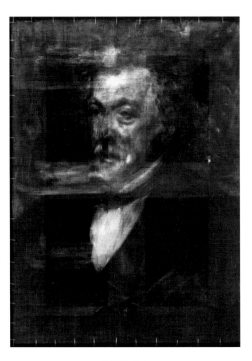

[FIG. 2]
Conservators discovered a finished portrait
beneath *Dance Rehearsal*.

from the portrait lying beneath the ballet scene begin to show through in their costumes, where the artist abraded the paint. The surface is also scraped from the dancer with her arms over her head. After removing paint, Degas did not completely repaint this figure. The white color in her upraised arm comes in part from the white shirt of the man in the portrait. Degas also slightly reworked the floor, covering some but not all of the dark lines of the floorboard in an ocher-colored paint. He partially covered the left side of the railing over the steps, but curiously did not paint over the right side. The ambiguity of this area in the painting is reinforced by the lack of finish to the uprights in the railing, which are indicated only by black outlines and are not painted brown as is the top horizontal bar.

–Elizabeth Steele

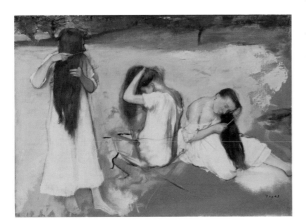

Edgar Degas
Women Combing Their Hair
c. 1875–76
Oil and *essence* on paper mounted on canvas[1]
12 ³/₄ x 18 ¹/₄ in.
Acquired 1940

Women Combing Their Hair is painted in oil and *essence*[2] on a prepared support of wove paper mounted to fine linen canvas. The paper is a standard nineteenth-century product, made up of very short bast and cotton fibers[3] and sized with alum.[4] It serves as the ground for the picture and is left exposed throughout much of the bottom half. It is not primed, oiled, or otherwise coated,[5] and has a soft, almost velvety surface with a hint of the underlying canvas tex-

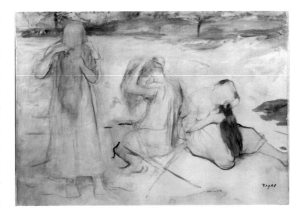

[FIG. 3]
Degas repositioned the arms, legs, and heads
of the women several times.

ture. Originally, the paper would have been a rosy-beige color, slightly lighter than the skin tone of the figures—but it has darkened significantly with age.

Degas began the picture with a light pencil study of the two figures on the left. An infrared image (fig. 3) shows the artist making multiple changes at this stage, characteristically experimenting with the positions of arms, hands, and feet. Some *pentimenti* of the preliminary pencil marks can even be seen in the finished painting, for example, near the left foot of the standing figure.

To establish the final poses of the two figures, Degas reinforced selected contours of the pencil sketch with calligraphic lines of fluid black paint. He also added the seated figure on the right at this point, drawing her contours directly in black paint, with no preliminary sketching or reworking in pencil.

To achieve the matte surface of *Women Combing Their Hair,* Degas used absorbent paper to remove excess oil medium from his paints. In some areas, he thinned the matted paint with turpentine, *à l'essence,* and applied it in sheer, dry strokes that skip over the subtle texture of the paper substrate. Using this technique, he blocked in the colors of the background and created translucence in the women's hair. Another example of *peintre à l'essence* is seen in the passage of thin, haphazard strokes of white paint along the left edge. In other areas, Degas used the matted paint without thinning it so that it retained body and opacity. When used for the women's dresses, the opaque paint layer stands out and emphasizes the figures against the more thinly painted areas, giving them prominence within the landscape.

Degas expertly manipulated his paint to achieve a variety of surfaces in the picture. In the background, he smeared, smoothed, and scraped the paint using a palette knife so that the color skipped over the surface of the paper, while just above his signature, he used a cloth or perhaps his finger to smooth the paint and blend it into the substrate. It is worth noting that even in areas where Degas used a palette knife, the soft velour surface of the paper is not burnished or otherwise disturbed, a testament to the artist's skill and further evidence of his desire to maintain a matte effect overall.

–Patricia Favero

Edgar Degas
After the Bath
c. 1895
Pastel on tracing paper,
attached to a secondary paper,
attached to board
33 3/8 x 30 7/8 in.
Acquired 1949

Degas drew *After the Bath* on thin, transparent paper, perhaps tracing over another image. This paper corresponds to the description of the *papier calque* or *papier vegetal* Degas used in his later pastels.[6] These types of papers were often made in France of flax, hemp, or fiber, then saturated with resin, gum, and oils to make them transparent. Indeed the first layer of paper of *After the Bath* fluoresces a yellow-green under ultraviolet light, indicating the presence of an oily substance in the paper.

Four additional pictures in the Paul-André Lemoisne catalogue illustrate the same pose and have similar dimensions to The Phillips Collection's *After the Bath*.[7] All four pictures are given roughly the same dates of execution, reinforcing the idea that all the images were traced from one original source. No monotype is detectable under the *After the Bath* pastel image. The drawing was probably done initially in the studio before mounting, as multiple layers of applied pastel extend beyond the edges of the paper, then subsequently trimmed before attachment to the mount. No tacking holes are visible in the paper. In the top-left corner, a small piece measuring ten millimeters by five millimeters is missing. The picture was probably attached at the edges to another support during its initial execution and trimmed later.

After the drawing was developed on the tracing paper, it was mounted overall, perhaps by a professional mounter,[8] onto a secondary paper, a brown, medium-weight wove paper which was wrapped around and attached overall to the five-millimeter board. Mounting necessitated a fairly wet procedure that was done once, possibly twice here, and most certainly affected the previously applied media. Often Degas applied fixative to his drawings before bringing them to the professional mounter.[9] In addition, the mounting procedure itself would have caused a certain "fixing" or "sinking" of the pastel medium. This change in appearance can be described as a more absorbed, less fluffy look to the underlayers of pastel in the picture. After the mounting procedure, additional pastel was applied over the original drawing. This is clearly seen in the presence of brown, black, white, pale blue, and deep blue pastel extending over the edges of the paper onto the mount. These layers of pastel have a fresher, drier, and more immediate look to them as they were applied over areas of previously fixed media and lie on top. Reserve areas of the paper below show through the design in many areas, and are especially notable in the lower-right quadrant of the picture. In raking light, a pattern of fine streaks is visible across the surface of the picture, possibly caused by smoothing or brushing out the picture during mounting.

One area of the brown backing paper is torn away along the right middle edge, exposing the construction of the paper layers and board underneath. The edge of the secondary paper shows that it is not brown all the way through, and is in fact a lighter color on the verso. This points toward the paper having darkened on the recto from application of fixative, age, and/or light exposure.

In raking light, the pastel gleams with varying degrees of intensity across the surface. Fixative has been applied generously to some areas and sparingly to others, and the artist built up layers of color. Most of the pastel does not appear to be highly friable at this point, and the picture is well fixed overall. Nevertheless, there are areas of more heavily applied pigment, possibly mixed with additional adhesive,[10] that are delicate and fragile when viewed under magnification. The most obvious of these areas is the white color on the top-left side.

The stamped signature was made using a resin or tempera medium and is slightly sparkly and pitted overall. The black color was one of the last added design elements and defines the figure shape over the various underlayers. The black has the silvery appearance of vine charcoal under magnification. There are other areas of color in the picture which look like they were applied with a brush in a liquid state, as in a pastel paste. These include the multilayers of blue and green in the bathtub and the water. There is a small clump of tiny brush hairs visible under magnification, attesting to the possibility of application of the pigment by this method.

The surface of the picture has been scored or stumped in many areas that are visible as wavy, shiny lines in raking light. These areas do not contain additional pigment but rather may have compressed the fixative or medium below and now taken on a burnished appearance.

–Sylvia Albro

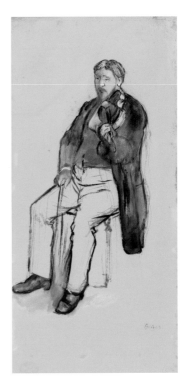

Edgar Degas
Seated Violin Player
1872
Oil (*essence*) over graphite pencil
on salmon pink painted paper attached to a
secondary support of pink wove paper
15 ³/₄ x 7 ⁷/₈ in.
Acquired 1983

When the drawing *Seated Violin Player* entered The Phillips Collection in 1983, it had been treated by at least one restorer. The top left quadrant had at one time been separated in two places from the bulk of the drawing paper, and the picture arrived at the museum repaired and lined with a pink secondary support paper and was lightly overpainted along the joins. The borders of the drawing displayed additional small damages and stains at the edges that had been overpainted. At the time of its accession into the museum's collection, the drawing was mounted around the edges to a wooden stretcher, a format likely created by the previous restorer, as the picture does not appear in this format in the 1919 sale catalogue of the drawing.[11] Because the artwork's secondary pink lining paper was wrapped

around the stretcher and pulled taught, both artwork and lining displayed strong draws at the corners and the museum conservators decided to release the drawing from the stretcher, trim the lining paper and re-house the picture in a traditional window mat format instead. The supplement to the Lemoisne catalogue describes this work as a "study for the violinist seated at the right, beside the ballet master in the painting *Le Foyer de la danse à l'Opéra de la rue Le Pelletier.*"[12]

The drawing was listed in the 1919 *Tableaux, Pastels et Dessins* sale catalogue as *Dessin gouaché,* and again in the *Degas et Son Oeuvre: A Supplement* in 1984 as "watercolor, gouache, and India ink." However, consultation with National Gallery of Art paper conservators in 1985 led to the correct identification of the media as oil (*essence*) over graphite pencil.[13] The determination of the media as oil was made through comparison with sample cards prepared by the National Gallery conservators of the various types of media used by Degas, along with examination in ultraviolet light. The latter clearly showed the typical fluorescence of oil within the painted lines and masses, as well as the movement of oil out into the surrounding areas of the paper. This "haloing" effect around the media is invisible to the unaided eye because of the very small amount of binder left in the paint.

–Sylvia Albro

[1] H Signed, bottom right, in black ink: "Degas"
Inscriptions on the reverse:
Four customs stamps on canvas reverse and adjacent stretcher bars:
Left: " Douane / Exportation / Paris / Centrale"
Right: "Douanes / Francaises / (two words illegible)"
Paper label, typed: "Mme H. Lerolle / Degas"
Paper label, handwritten, blue crayon: "Mme Lerolle / 20 Av Duquesne"
Paper label, printed: "(LEFEB)VRE-FOINET / RUE BRÉA P(ARIS) VIE / 1453 / COULEURS ET TOILES FINES" (applied over framer's tape).

[2] *Essence* is defined as "oil paint from which most of the oil has been soaked out on blotting paper and then diluted with turpentine to give an effect similar to watercolour; used almost always on a paper support." David Bomford et al., *Art in the Making: Degas* (London: National Gallery Publications, 2004), 159.

[3] Identified by Sylvia Albro using polarized light microscopy.

[4] Most likely aluminum sulfate in an alum-rosin size, the presence of alum was confirmed by a strong positive result to the aluminon test performed by Sylvia Albro. At the end of the nineteenth century, aluminum sulfate would have commonly been used as a component of alum-rosin sizing. See Irene Brückle, "The Role of Alum in Historical Paper Making," *The Abbey Newsletter* 17, no. 4 (September 1993).

[5] Under ultraviolet illumination, the bare paper exhibits absolutely no fluorescence, in contrast to even the thinnest passages of paint, indicating a complete lack of any priming, oiling, or coating material.

[6] Jean Sutherland Boggs and Anne Maheux, *Degas Pastels* (New York: Braziller, 1992), 25.

[7] Paul-André Lemoisne, *Degas et son oeuvre* (New York: Garland Publishing, 1984), 700.

[8] Boggs and Maheux, *Degas Pastels,* 25. Anne Maheux, *Degas Pastels* (Ottawa: National Gallery of Canada, 1988), 45–46.

[9] Maheux, *Degas Pastels,* 45. Boggs and Maheux, *Degas Pastels,* 31.

[10] Boggs and Maheux, *Degas Pastels,* 31–33. Shelley Fletcher and Pia de Santis, "Degas: The Search for His Technique Continues," *The Burlington Magazine* 131, no. 1033 (April 1989): 256–65.

[11] Records of the 1919 third auction of Degas's studio contents include this drawing showing the dimensions of the picture to be larger at the time of the sale. The drawing was also part of a trio of drawings listed together under one number.

[12] Philippe Brame and Theodore Reff, *Degas et Son Oeuvre, A Supplement* (New York and London: Garland Publishing, Inc., 1984), entry 61.

[13] Noted in The Phillips Collection condition reports for *Seated Violin Player.*

CHRONOLOGY

1834

Born July 19, named Hilaire Germain Edgar De Gas after his paternal grandfather, Hilaire Degas, and his maternal grandfather, Germain Musson.

1845

Enters the Lycée Louis-le-Grand, a prestigious secondary school in Paris, where he begins lifelong friendship with classmate Henri Stanislas Rouart.

1853

Graduates from the Lycée Louis-le-Grand in March and registers in the department of prints at the Bibliothèque nationale de France and the department of drawings in the Musée du Louvre for permission to study and make copies of artists' works. Enrolls in the Faculté de droit (law school) in November to appease his father, though he most likely did not attend class.

1854

Copies Raphael's *Portrait of a Young Man,* among other old master paintings, stating, "The masters must be copied again and again, and only after having given every indication of being a good copyist can you reasonably be given leave to draw a radish from nature."

1855

Admitted to the highly regarded École des Beaux-Arts and is taught drawing by Louis Lamothe, a student of Jean-Auguste-Dominique Ingres and Hyppolyte-Jean Flandrin. Travels with Edouard Valpinçon to visit Ingres, whom Degas venerates.

1856

Learns the basics of etching from Prince Grégoire Soutzo, an engraver and friend of Degas's father. Travels to Rome, where he attends art classes at the Académie Française at the Villa Medici. Engages with two famed sculptors, Jean-Baptiste Carpeaux and Henri Michel Antoine Chapu.

1857–58

Befriends artist Gustave Moreau in Italy, who offers inspiration and reputedly introduces Degas to pastels.

1858

Moves in with the family of his aunt, Laura Bellelli, over the summer in Florence. Produces studies for his well-known family portrait, *The Bellelli Family* (1858–67).

1859

Returns to Paris. Lives briefly with his father before moving into his own studio at 13 rue de Laval in Saint-Georges. Begins creating sculpture as he enters the public art world.

1860

Drawing heavily from the influences of Ingres and the Italian masters, Degas produces paintings representing mythological themes and legends, such as *The Daughter of Jephthah* (1859–61), *Semiramis Building Babylon* (c. 1860–62), and *Young Spartans Exercising* (c. 1860).

1861

Visits Paul Valpinçon in Normandy and observes the world of horses and horse racing for the first time.

1862

Meets Édouard Manet at the Musée du Louvre, where they were both allegedly copying Diego Velázquez's *Infanta Maria Margarita* (1653–54). Manet's practice of depicting the contemporary world becomes an influence for Degas. The two painters begin an amicable yet stormy relationship, climaxing in the late 1860s when Manet cut the face of his wife out of a double portrait Degas had given him.

1865

Shows the history painting *Scene in a Medieval War* (1865) as his first work at the Salon.

1866

Finishes painting historical compositions and becomes more interested in portraiture. Paints strictly from contemporary life or from copies of other artists' works from this point forward.

1868

Exhibits a painting of the infamous personality Eugénie Fiocre, *Portrait of Mlle Fiocre in the Ballet "La Source"* (1867–68), at the Salon, launching his reputation as a dance artist. Frequents Café Guerbois at 11 grande rue des Batignolles with other avant-garde artists such as Frédéric Bazille, Paul Cézanne, Henri Fantin-Latour, Manet, Claude Monet, Camille Pissarro, Pierre-Auguste Renoir, and Alfred Sisley.

1870

Submits *Madame Camus in Red* (1870) and *Madame Théodore Gobillard* (1869) as his last entries to the Salon. Begins to focus on the subject of ballerinas. Volunteers in the Franco-Prussian War.

1870s

Begins making sculptures of dancers. Stops signing his name as De Gas, and contracts it into Degas. Degas was his grandparents' original name; however, his father changed names upon moving to Paris to elevate his social status.

1872

Moves to 77 rue Blanche. Travels with his brother René Degas to America, where he spends several months in New Orleans and where he is inspired to paint *Portraits in an Office: The Cotton Exchange, New Orleans* (1873). For the first time, the art dealer Paul Durand-Ruel purchases three of Degas's works directly from the artist, including *Dance Class at the Opéra* (1872), which was also displayed in the *Fifth Exhibition of the Society of French Artists* in London.

1873

Begins *The Dance Class* (c. 1873). Founds the Société anonyme coopérative à capital variable des artistes peintres, sculpteurs, graveurs, etc. (the Société anonyme des artistes), with Cézanne, Monet, Berthe Morisot, Pissarro, and Sisley, among others, to display their artwork in nonjuried shows, sell their exhibited works, and publish an art journal.

1874

Co-organizes the first impressionist exhibition, the first of eight annual exhibitions, which garners valuable recognition, amidst much criticism, for Degas and his peers. Shows ten pieces alongside works by his colleagues and begins to stand out among his contemporaries. Depends immensely on the exposure of his works through this exhibition and on the profits of sold works as he assumes responsibility for his family's debt, stemming from the bankruptcy of his deceased father's bank.

1875

Attends productions at the new Paris Opéra, known as the Palais Garnier. Returns to printmaking, specifically experimenting with the drypoint technique, after connecting with the painter-printmaker Marcellin Desboutin.

1876

Actively creates monotypes and prints. Exhibits twenty-two works, possibly including *Dance Rehearsal* (1873) and *Dancers Practicing in the Foyer* (1875–1900), in the second impressionist exhibition at the Galerie Durand-Ruel. Has befriended Edmond Duranty by this time, who writes a pamphlet related to issues concerning academic painting and the Salon and to the important role of avant-garde artists, such as Degas, in renewing the study, practice, and subject matter of painting.

1877

Moves to 50 rue Lepic. Begins to use pastel more frequently due to his declining eyesight and his personal preferences: pastels were sufficiently dry for his hastiness and adequately opaque for his habit of revising. Exhibits three groups of monotypes and twenty-three paintings and pastels at the third impressionist exhibition, including *Dancers Practicing at the Bar* (1877).

1878

The Musée de Pau acquires *Portraits in an Office: The Cotton Exchange, New Orleans* (1873), Degas's first painting to become part of a public collection. A collector and friend of Mary Cassatt, Louisine Havemeyer, contributes *Ballet Rehearsal* (1876–77) to the *Eleventh Annual Exhibition of the American Water-color Society* in New York, Degas's first work to be shown in North America.

1879

Begins producing works on long, rectangular canvases, creating a new compositional format.

1881

Exhibits four paintings and works on paper and the only sculpture he ever displayed publicly—*Little Dancer Aged Fourteen* (1878–81), which receives mixed reviews—in the sixth impressionist exhibition.

1882

Moves to 21 rue Pigalle. Sells twelve studies of dancers to Durand-Ruel for 2,450 francs.

1885

Takes a trip to Dieppe where he meets Paul Gauguin, for whom he initially has an aversion, but grows fond of over time.

1886

Submits a group of ten pastel nudes to the eighth and final impressionist exhibition in Paris, earning him much critical acclaim and scandal and leading to the end of his career as a public artist. Stops exhibiting his works in independent shows with fellow artists and begins to rely on programs organized by dealers in Europe and America. Frequently attends the Paris Opéra to view ballets and operas.

1887

Theo van Gogh purchases the Galerie Boussod et Valadon's first work by Degas, *Woman Leaning near a Vase of Flowers* (1865), for four thousand francs and continues to acquire Degas's pastels and paintings over the next three years.

1888

Exhibits at least nine pastels of bathers at Galerie Boussod et Valadon. Engraver George William Thornley publishes four lithographs inspired by Degas: three works of dancers and one print of a woman bathing. Prints are shown at Boussod et Valadon.

1888–90

Moves to 18 rue de Boulogne. Begins writing poetry in the form of sonnets with the subjects of animals and people from his works of art, namely horses, dancers, and singers.

1889

Travels to Spain with Giovanni Boldini to visit the Museo del Prado. Also travels to Morocco. *The Dance Class* (c. 1873) and *Dance Rehearsal* (1873) held by Henry Hill of Brighton are sold at Christie's in London, along with five additional works by Degas and the entirety of Hill's private collection. Attends the Paris Opéra less frequently.

1890

Rents a studio at 37 Victor Massé in Montmartre, and leases a new apartment nearby. Begins a series of his first color landscape monotypes after a trip to Diénay in Burgundy with Albert Bartholomé.

1890s

Begins developing his personal art collection, which ultimately includes works by Jean-Baptiste-Camille Corot, Honoré Daumier, Eugène Delacroix, Gauguin, El Greco, Ingres, Manet, Pissarro, Renoir, Henri Rousseau, and Sisley.

1891

Paints less frequently with oils and begins to use pastels almost exclusively. Turns back to lithography for a year after being prompted by the *General Exhibition of Lithography* held at the École des Beaux-Arts, as well as fellow artists. Employs complicated experimental techniques, in lieu of simplified procedures, to create the series of prints *After the Bath*.

1892

Holds a solo exhibition of his landscapes at Durand-Ruel: the first of only two one-man shows in his lifetime. Travels to Belgium, Normandy, Pau, and Switzerland. Stops attending dance rehearsals and performances at the Paris Opéra.

1895

Begins seriously pursuing photography as a medium, setting up compositions using tripods, glass plates, dim light, and long exposures. Mary Cassatt alleges that "Degas works as much as ever."

1897

Has combined his living and working arrangements at 37 Victor Massé in Montmartre by this time. Travels to Montauban, near Toulouse, to visit the Ingres Museum. Splits with longtime friends the Halévys over the Dreyfus Affair.

1900

Refuses to exhibit in the *Centennial Exhibition;* however, the show includes a small group of his works. After this year, dancers and bathers become his primary subject matter among all mediums.

1901

In New York, Durand-Ruel organizes one of the earliest impressionist exhibitions to be photographed, featuring Degas's work.

1903

With the assistance of Mary Cassatt, Louisine Havemeyer attempts to purchase Degas's wax of *Little Dancer Aged Fourteen.*

1907

Begins painting on larger canvases given his weak eyesight. Notes in letter that he "trace[s] and retrace[s]" and that "journeys do not tempt me anymore."

1911

Fogg Museum of Harvard University organizes the second Degas retrospective during his lifetime with twelve works.

1912

Unwillingly abandons his studio and ends his artistic pursuits. Moves to an apartment at 6 boulevard de Clichy, as his Victor Massé residence is slated for demolition. Sees his *Dancers at the Barre* (c. 1873, The British Museum, London) sell for 478,000 francs at the sale of Henri Stanislas Rouart's collection.

1914

Parisian art dealer Ambroise Vollard's album of ninety-eight works by Degas is published.

1917

Dies September 27 from cerebral congestion.

Chronology drawn from:

Jean Sutherland Boggs, *Degas* (Chicago: Art Institute of Chicago, 1996)

Jill DeVonyar and Richard Kendall, *Degas and the Dance* (New York: Harry N. Abrams in association with the American Federation of Arts, 2002)

Francois Fosca, "Chronological Survey," in *Degas: Biographical and Critical Studies* (Geneva: Albert Skira, 1954)

Robert Gordon and Andrew Forge, *Degas* (New York: Harry N. Abrams, 1996)

Richard Kendall, *Degas: Beyond Impressionism* (London: National Gallery Publications, 1996)

Suzanne Glover Lindsay, Daphne Barbour, and Shelley Sturman, *Edgar Degas Sculpture.* The Collections of the National Gallery of Art Systematic Catalogue (Washington, DC: National Gallery of Art, 2010).

Henri Loyrette, *Degas: The Man and His Art* (New York: Harry N. Abrams, 1993)

Sue Welsh Reed and Barbara Stern Shapiro, *Edgar Degas: The Painter as Printmaker* (Boston: Museum of Fine Arts, 1984)

Anna Gruetzner Robins and Richard Thomson, *Degas, Sickert, and Toulouse-Lautrec: London and Paris, 1870–1910* (London: Tate Gallery Publications, 2005), 25–29.

Richard Thomson, *Degas: The Nudes* (New York: Thames and Hudson, 1988)

EXHIBITION
CHECKLIST

PAINTINGS

Melancholy
Late 1860s
Oil on canvas
7 ½ x 9 ¾ in. (19.1 x 24.8 cm)
The Phillips Collection, Acquired 1941
Cat. 29

Dance Rehearsal
1873
Oil on canvas
16 x 21 ½ in. (40.6 x 54.6 cm)
The Phillips Collection, Gift of anonymous donor,
Completed 2006
Cat. 5

The Dance Class
c. 1873
Oil on canvas
18 ¾ x 24 ½ in. (47.6 x 62.2 cm)
Corcoran Gallery of Art, Washington, D.C.,
William A. Clark Collection, 26.74
Cat. 6

Dancers Practicing in the Foyer
1875–1900
Oil on canvas
28 x 34 ⅝ in. (71.1 x 87.9 cm)
Ny Carlsberg Glyptotek, Copenhagen
Cat. 7

Women Combing Their Hair
c. 1875–76
Oil and *essence* on paper mounted on canvas
12 ¾ x 18 ⅛ in. (32.4 x 46 cm)
The Phillips Collection, Acquired 1940
Cat. 30

Dancers at the Barre
Early 1880s–c. 1900
Oil on canvas
51 ¼ x 38 ½ in. (129.5 x 96.5 cm)
The Phillips Collection, Acquired 1944
Cat. 1

Ballet Rehearsal
c. 1885–91
Oil on canvas
18 ⅞ x 34 ⅝ in.
Yale University Art Gallery,
Gift of Duncan Phillips, B.A. 1908
Cat. 9

PASTELS, DRAWINGS AND MIXED MEDIA

Seated Violin Player
1872
Oil (*essence*) over graphite pencil on paper
15 ¾ x 7 ⅞ in. (40 x 20 cm)
The Phillips Collection, Bequest of June P. Carey, 1983
Cat. 28

Two Dancers
1873
Dark brown wash and white gouache on bright pink
commercially coated wove paper, now faded to pale pink
24 ⅛ x 15 ½ in. (61.3 x 39.4 cm)
Metropolitan Museum of Art, H.O. Havemeyer Collection,
Bequest of Mrs. H.O. Havemeyer, 1929
Cat. 8

Two Studies of a Ballet Dancer
c. 1873
Brush and brown ink, heightened with white, on pink
paper, now faded
16 ¹/₁₆ x 11 ¹/₁₆ in. (40.9 x 28.2 cm)
The Morgan Library and Museum, New York,
Bequest of John S. Thacher, 1985.40
Cat. 4

Dancer Onstage with a Bouquet
c. 1876
Pastel over monotype on laid paper
10 ⅝ x 14 ⅞ in. (27 x 37.8 cm)
Private Collection
Cat. 13

Study of a Nude Dancer
c. 1878–79 or later
Black chalk and charcoal on mauve-pink laid paper
18 ⁵/₈ x 12 ¼ in. (47.3 x 31 cm)
National Museum of Art, Architecture and Design, Oslo
Cat. 26

Nude Study—Two Dancers Seated
c. 1880
Charcoal on paper
13 ¼ x 18 ³/₈ in. (33 x 45.7 cm)
Private Collection, London,
Courtesy of Connaught Brown Gallery
Cat. 11

The Ballet
c. 1880
Pastel on light tan laid paper, mounted on board
12 ³/₄ x 10 in. (32.4 x 25.4 cm)
Corcoran Gallery of Art, Washington, D.C.,
William A. Clark Collection, 26.71
Cat. 14

Dancer Adjusting Her Shoe
1885
Pastel on paper
19 x 24 in. (48.3 x 70 cm)
Dixon Gallery and Gardens, Memphis, Tennessee,
Bequest of Mr. and Mrs. Hugo Dixon
Cat. 12

Three Dancers
c. 1889
Charcoal and pastel on blue-gray paper
23 ¼ x 17 ¹¹/₁₆ in. (59 x 45 cm)
Museum of Fine Arts, Boston,
Bequest of John T. Spaulding, 48.872
Cat. 22

Two Dancers Resting
c. 1890–95
Charcoal on paper
22 ³/₄ x 16 ³/₈ in. (58 x 41.7 cm)
Private Collection, Courtesy of Sotheby's, New York
Cat. 20

Two Dancers Resting
c. 1890–1900
Charcoal and colored chalk or pastel on paper
22 ¹/₄ x 17 ¹/₂ in. (56.5 x 44.5 cm)
Philadelphia Museum of Art,
The Samuel S. White III and Vera White Collection, 1967
Cat. 19

After the Bath
1891–92
Lithographic crayon and graphite, with touches of black
wash on pale pink Japan transfer paper
13 ⁷/₈ x 12 ¹⁵/₁₆ in. (35 x 32.8 cm)
The British Museum, London
Cat. 15

Study of a Nude Dancer at the Barre
1895–98
Pastel and charcoal on paper, laid down on board
46 ⁷/₈ x 33 ⁷/₈ in. (119 x 86 cm)
Herbert and Nell Singer Foundation, Inc., New York
Cat. 3

Dancers
c. 1900
Pastel
24 ½ x 19 in. (62.2 x 48.3 cm)
Private Collection

Dancers at the Barre
c. 1900
Charcoal and pastel, laid down on cardboard
49 ¹/₄ x 42 ¹/₈ in. (125.1 x 107 cm)
National Gallery of Canada, Ottawa, Purchased 1921
Cat. 2

Dancers in Rose
c. 1900
Pastel on paper
33 ¹/₈ x 22 ⁷/₈ in. (84.1 x 58.1 cm)
Museum of Fine Arts, Boston, Seth K. Sweetser Fund,
20.164
Cat. 27

Dancers in the Rehearsal Room
1900–1905
Charcoal with pastel on paper mounted on cardboard
17 ⁷/₈ x 33 ¹/₂ in. (45.4 x 85.1 cm)
Museum of Fine Arts, Boston,
Gift of Arthur Wiesenberger, 54.1557
Cat. 10

Dancers in Green and Yellow
c. 1903
Pastel on several pieces of tracing paper, mounted on board
38 ⁷/₈ x 28 ¹/₈ in. (98.8 x 71.5 cm)
Solomon R. Guggenheim Museum, New York,
Thannhauser Collection,
Gift of Justin K. Thannhauser, 1978, 78.2514.12
Cat. 21

PRINTS

After the Bath
1891–92
Lithograph
7 ½ x 5 ¾ in. (19 x 14.7 cm)
The British Museum, London
Cat. 16

Nude Woman Standing, Drying Herself
1891–92
Lithograph, third state
19 ¹¹/₁₆ x 11 ¼ in. (50 x 28.5 cm)
Harvard Art Museums/Fogg Museum,
Gray Collection of Engravings Fund, G8830
Cat. 17

Nude Woman Standing, Drying Herself
1891–92
Lithograph, sixth state
16 ¾ x 12 in. (42.5 x 30.5 cm)
Harvard Art Museums/Fogg Museum,
Bequest of Paul J. Sachs, M14294
Cat. 18

SCULPTURE

Nude Study for Little Dancer Aged Fourteen
Original wax c. 1878–81
Bronze
28 ¹¹/₁₆ x 13 ⁷/₈ x 10 ¹³/₁₆ in. (72.8 x 35.2 x 27.4 cm)
Private Collection
Cat. 24

Dancer Moving Forward, Arms Raised
Original wax c. 1882–98
Bronze
13 ³/₄ x 6 ⁷/₈ x 6 in. (35 x 17.5 x 15.1 cm)
Hirshhorn Museum and Sculpture Garden,
Smithsonian Institution, Washington, D.C.,
Gift of Joseph H. Hirshhorn, 1966
Cat. 25

Dancer Holding Her Right Foot in Her Right Hand
Original wax c. 1900–1911
Bronze
19 ¹³/₁₆ x 9 ½ x 14 ¹³/₁₆ in. (50.4 x 24.2 x 37.6 cm)
Private Collection
Cat. 23

ADDITIONAL WORKS
BY DEGAS

PAINTINGS

The Dance Lesson
c. 1879
Oil on canvas
14 $^{15}/_{16}$ x 34 $^{5}/_{8}$ in (38 x 88 cm)
National Gallery of Art, Washington D.C.
Collection of Mr. and Mrs. Paul Mellon
Fig. 6, p. 33

Nude Women Drying Herself
c. 1884–86
Oil on canvas
59 $^{3}/_{8}$ x 84 $^{1}/_{8}$ in. (150.8 x 213.7 cm)
Brooklyn Museum
Carll H. de Silver Fund, 31.813
Fig. 15, p. 65

Before the Ballet
1890/92
Oil on canvas
15 ¾ x 35 in. (40 x 88.9 cm)
National Gallery of Art, Washington, D.C.
Widener Collection, 1942.9.19
Fig. 7, p. 34

PASTELS, DRAWINGS, AND MIXED MEDIA

Dancers Practicing at the Barre
1877
Mixed media on canvas
29 $^{3}/_{4}$ x 32 in. (75.6 x 81.3 cm)
The Metropolitan Museum of Art
H. O. Havemeyer Collection, Bequest of Mrs. H. O. Havemeyer, 1929
Fig. 2, p. 19

Dancer at the Barre
1884–88
Pastel on paper
43 $^{1}/_{3}$ x 24 $^{2}/_{5}$ in. (110 x 62 cm.)
Private collection
Fig. 1, p. 19

Dancer at the Barre
1884–88
Charcoal heightened with pastel on paper
41 x 29 ½ in. (104.1 x 75 cm)
Private Collection
Fig. 12, p. 64

After the Bath
c. 1891–92
Charcoal on yellow tracing paper
18 $^{7}/_{8}$ x 10 in. (35.2 x 25.4 cm)
Sterling and Francine Clark Art Institute, Williamstown
Fig. 9, p. 44

After the Bath
c. 1895
Pastel on paper
30 $^{1}/_{2}$ x 33 $^{1}/_{8}$ in. (77.5 x 84.1) cm
The Phillips Collection, Washington, D.C.
Acquired 1949
Fig. 1, p. 111

Nude Study for Dancer at the Barre
c. 1895–1900
Charcoal on paper
Location unknown
Fig. 3, p. 20

PRINTS

Three Ballet Dancers
c. 1878–80
Monotype on paper
7 7/8 x 16 7/16 in. (20 x 41.7 cm)
Sterling and Francine Clark Art Institute, Williamstown
Acquired by Sterling and Francine Clark, 1922
Fig. 8, p. 43

SCULPTURES

Little Dancer Aged Fourteen
1878–81
Pigmented beeswax, clay, metal armature, human hair,
silk and linen ribbon, cotton and silk tutu, cotton bodice,
linen slippers, on wooden base
Overall without base 38 15/16 x 13 11/16 x 13 7/8 in.
(98.9 x 34.7 x 35.2 cm)
National Gallery of Art, Washington, D.C.
Collection of Mr. and Mrs. Paul Mellon
Fig. 1, p. 76

Dancer Moving Forward, Arms Raised,
Right Leg Forward
Original wax 1882–95
Bronze
26 x 12 1/2 x 9 1/16 in. (66 x 31.8 x 22.9 cm)
Norton Simon Art Foundation, M.1977.02.18.S
Fig. 4, p. 82

Dancer Looking at the Sole of Her Right Foot
Original wax c. 1890s
Four bronze versions
18 x 10 1/4 x 7 3/16 in. (45.7 x 26 x 18.2 cm)
National Gallery of Art, Washington, D.C.; Musée d'Orsay,
Paris; Virginia Museum of Fine Arts, Richmond; lost (wax
no longer extant)
Fig. 7, p. 85

SELECTED
BIBLIOGRAPHY

MONOGRAPHS AND BOOKS

Boggs, Jean Sutherland. *Degas*. Chicago: Art Institute of Chicago, 1996.

Boggs, Jean Sutherland, and Anne F. Maheux. *Degas Pastels*. New York: George Braziller, 1992.

Gimpel, René. *Journal d'un collectionneur, marchand de tableaux*. Paris: Calmann-Lévy, 1963.

Brame, Philippe, and Theodore Reff. *Degas et son oeuvre: A Supplement*. New York: Garland Publishing, 1984.

Gordon, Robert, and Andrew Forge. *Degas*. New York: Harry N. Abrams, 1996.

Guérin, Marcel. *Edgar Germain Hilaire Degas: Letters*. Translated by Marguerite Kay. Oxford: Bruno Cassirer, 1947.

Kendall, Richard. *Degas Backstage*. London: Thames and Hudson, 1996.

Kendall, Richard. *Degas by Himself: Drawings, Prints, Paintings, Writings*. Edison, NJ: Chartwell Books, 2005.

Kendall, Richard. *Degas Dancers*. New York: Universe, 1996.

Kendall, Richard, and Griselda Pollock. *Dealing with Degas: Representations of Women and the Politics of Vision*. Liverpool: Tate Gallery Publication in association with Pandora Press, London, and Universe, 1992.

Lemoisne, Paul-André. *Degas et son œuvre*. New York: Garland Publishing, 1984.

Loyrette, Henri. *Degas: The Man and His Art*. New York: Harry N. Abrams, 1993.

Millard, Charles W. *The Sculpture of Edgar Degas*. Princeton, NJ: Princeton University Press, 1976.

Pingeot, Anne. *Degas: Sculptures*. Paris: Réunion des musées nationaux, 1991.

Reff, Theodore. *The Notebooks of Edgar Degas: A Catalogue of the Thirty-Eight Notebooks in the Bibliothèque Nationale and Other Collections*. Oxford: Clarendon Press, 1976.

Rouart, Denis. *Degas à la recherche de sa technique*. Paris: Floury, 1945.

Thomson, Richard. *Degas: The Nudes*. New York: Thames and Hudson, 1988.

Vollard, Ambroise. *Degas (1834–1917)*. Paris: Les Editions G. Crès et Cie, 1924.

Vollard, Ambroise. *Recollections of a Picture Dealer*. Boston: Little, Brown and Company, 1936.

Vollard, Ambroise. *Degas: An Intimate Portrait*. New York: Crown Publishers, 1937.

COLLECTION AND EXHIBITION CATALOGUES

Boggs, Jean Sutherland, Douglas Druick, Henri Loyrette, Michael Pantazzi, and Gary Tinterow. *Degas*. New York: Metropolitan Museum of Art in association with the National Gallery of Canada, Ottawa, 1988. Exhibition catalogue.

Bomford, David, Sarah Herring, Jo Kirby, Christopher Riopelle, and Ashok Roy. *Art in the Making: Degas*. London: National Gallery Publications, 2004. Exhibition catalogue.

Campbell, Sara, Richard Kendall, Daphne Barbour, and Shelley Sturman. *Degas in the Norton Simon Museum*. Nineteenth-Century Art, vol. 2. New Haven, CT: Yale University Press, 2009.

Czestochowski, Joseph S., and Anne Pingeot. *Degas Sculptures: Catalogue Raisonné of the Bronzes*. Memphis: International Arts in association with Torch Press, 2002.

DeVonyar, Jill, and Richard Kendall. *Degas and the Dance*. New York: Harry N. Abrams in association with the American Federation of Arts, 2002. Exhibition catalogue.

Dixon, Annette, Mary Weaver Chapin, Jill DeVonyar, Richard Kendall, and Florence Valdes-Forain. *The Dancer: Degas, Forain, and Toulouse-Lautrec*. Portland, OR: Portland Art Museum, 2008. Exhibition catalogue.

Dumas, Ann, Colta Ives, Susan Alyson Stein, and Gary Tinterow. *The Private Collection of Edgar Degas*. New York: Metropolitan Museum of Art, 1997. Exhibition catalogue.

Gross, Jennifer, Suzanne Boorsch, and Richard Kendall. *Edgar Degas: Defining the Modernist Edge*. New Haven, CT: Yale University Art Gallery in association with Yale University Press, 2003.

Ives, Colta, Susan Alyson Stein, and Julie A. Steiner. *The Private Collection of Edgar Degas: A Summary Catalogue*. New York: Metropolitan Museum of Art, 1997. Exhibition catalogue.

Janis, Eugenia Parry. *Degas Monotypes: Essay, Catalogue and Checklist*. Cambridge, MA: Fogg Art Museum, Harvard University, 1968. Exhibition catalogue.

Kendall, Richard. *Degas: Beyond Impressionism*. London: National Gallery Publications, 1996. Exhibition catalogue.

Kendall, Richard, Anthea Callen, and Dillian Gordon. *Degas: Images of Women*. Liverpool: Tate Gallery Publications, 1989. Exhibition catalogue.

Kendall, Richard, Douglas W. Druick, and Arthur Beale. *Degas and the Little Dancer*. Omaha, NE: Joslyn Art Museum, 1998. Exhibition catalogue.

Lindsay, Suzanne Glover, Daphne S. Barbour, and Shelley G. Sturman. *Edgar Degas Sculpture*. The Collections of the National Gallery of Art Systematic Catalogue. Washington, DC: National Gallery of Art, 2010.

Maheux, Anne F. *Degas Pastels*. Ottawa: National Gallery of Canada, Ottawa, 1988. Exhibition catalogue.

Moffett, Charles S., Ruth Berson, Barbara Lee Williams, and Fronia E. Wissman. *The New Painting, Impressionism, 1874–1886: An Exhibition Organized by the Fine Arts Museums of San Francisco with the National Gallery of Art, Washington*. San Francisco: The Fine Arts Museums of San Francisco, 1986. Exhibition catalogue.

Muehlig, Linda D. *Degas and the Dance: April 5–May 27, 1979, Smith College Museum of Art, Northampton, Massachusetts: Exhibition and Catalogue*. Northampton, MA: Smith College Museum of Art, 1979. Exhibition catalogue.

Reed, Sue Welsh, and Barbara Stern Shapiro. *Edgar Degas: The Painter as Printmaker*. Boston: Museum of Fine Arts, 1984. Exhibition catalogue.

Reff, Theodore. *Degas: The Artist's Mind*. New York: Metropolitan Museum of Art, 1976. Exhibition catalogue.

Robins, Anna Gruetzner, and Richard Thomson. *Degas, Sickert, and Toulouse-Lautrec: London and Paris, 1870–1910*. London: Tate Gallery Publications, 2005. Exhibition catalogue.

Shackelford, George T. M. *Degas: The Dancers*. Washington, DC: National Gallery of Art in association with W. W. Norton, 1984. Exhibition catalogue.

Thomson, Richard. *The Private Degas*. Manchester: Whitworth Art Gallery, University of Manchester, in association with Herbert Press and Thames and Hudson, 1987. Exhibition catalogue.

ARTICLES AND BOOK CHAPTERS

Barbour, Daphne. "Degas's Little Dancer: Not Just a Study in the Nude." *Art Journal* 54, no. 2 (Summer 1995): 28–32.

Cortissoz, Royal. "Degas as He Was Seen by His Model." *New York Tribune,* section IV, (October 19, 1919): 9.

Fletcher, Shelley, and Pia Desantis. "Degas: The Search for His Technique Continues," *The Burlington Magazine* 131, no. 1033 (April 1989): 256–265.

Fosca, François. "Chronological Survey." In *Degas: Biographical and Critical Studies,* 5–9. Geneva: Albert Skira, 1954.

Huysmans, Joris-Karl. "L'Exposition des indépendants en 1881." In *L'Art Moderne,* 226. Paris: G. Charpentier, 1883.

Janis, Eugenia Parry. "The Role of the Monotype in the Working Method of Degas—I," *The Burlington Magazine* 109, no. 766 (January 1967): 20–27, 29.

Lockhart, Anne I. "Three Monotypes by Edgar Degas." *Bulletin of the Cleveland Museum of Art* 64, no. 9 (November 1977): 299–306.

Luchs, Alison. "The Degas Waxes c. 1878–c. 1911." In *Art for the Nation: Gifts in Honor of the Fiftieth Anniversary of the National Gallery of Art,* 178–211. Washington: National Gallery of Art, 1991.

Meller, Mari Kálmán. "Exercises in and around Degas's Classrooms: Part I," *The Burlington Magazine* 130, no. 1020 (March 1988): 198–215.

Michel, Alice. "Degas et son modèle." *Le Mercure de France* 131 (February 1, 1919): 457–78, 623–29.

Moore, George. "Memories of Degas (Conclusion)." *The Burlington Magazine* 32, no. 179 (February 1918): 63–65.

Pickvance, Ronald. "Some Aspects of Degas's Nudes." *Apollo* 83, no. 47 (January 1966): 17–23.

Reff, Theodore. "Degas's Copies of Older Art." *The Burlington Magazine* 105, no. 723 (June 1963): 238, 241–251.

Reff, Theodore. "The Pictures within Degas's Pictures." *Metropolitan Museum Journal* 1 (1968): 125–166.

Reff, Theodore. "The Technical Aspects of Degas's Art." *Metropolitan Museum Journal* 4 (1971): 141–66.

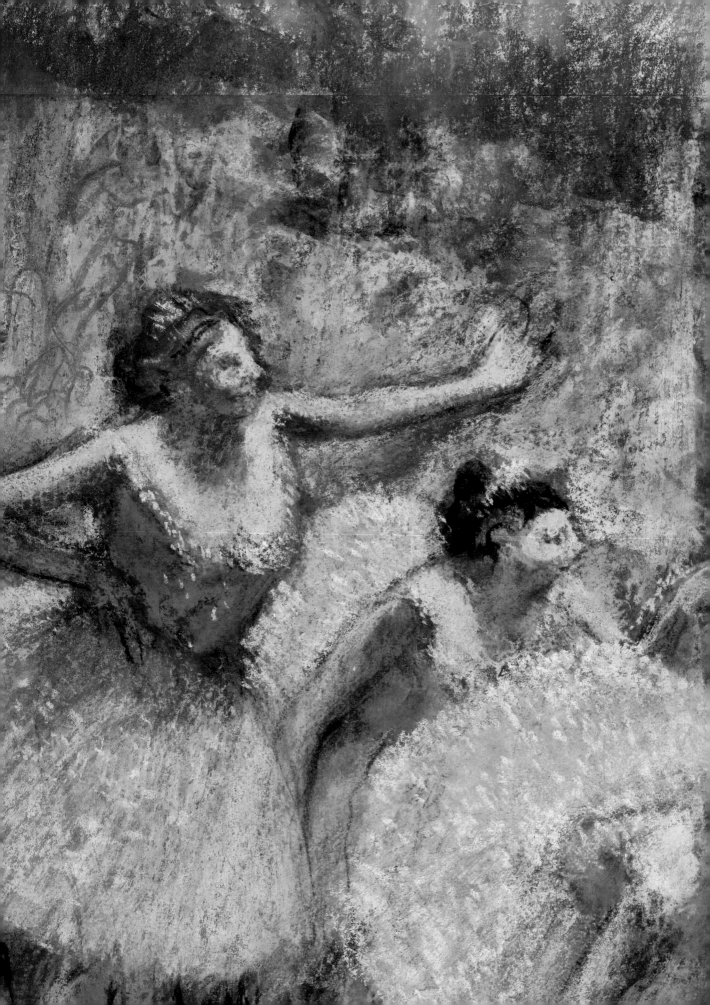

CONTENTS

FOREWORD

This exhibition and publication is exemplary of the intellectual and aesthetic identity of The Phillips Collection. It is a celebration of one of the great masterworks in the collection, a late large-scale painting by Edgar Degas, *Dancers at the Barre*. At the heart of the project is riveting new knowledge derived from detailed technical examinations by conservators, including analysis with infrared reflectography and x-radiography. What began with an urgent conservation treatment to address issues of aging varnish, flaking paint, and grimy surface film has resulted in a profoundly enriched understanding of the work and of the artist's process in the studio. Painstaking examination reveals that Degas worked and reworked this painting during a period of up to sixteen years, starting around 1884 and perhaps lasting as late as 1900. The palette became more intense, the positioning of arms and legs changed repeatedly, and the format of the canvas itself was cut down. Clearly, Degas was totally absorbed in the manipulation, refinement, and perfection of this magnificent composition.

The exhibition provides, furthermore, a rich context of approximately thirty carefully selected additional works. This assemblage reveals Degas's enduring, obsessive delight in the subject of ballet, as well as his experimental working process across media including painting, monotype, lithography, drawing, pastel, and sculpture. The success of the exhibition is, of course, due to the incredible generosity of the lenders, twenty-three public and private collections from across North America, Denmark, Norway, and the United Kingdom. It is very special to be able to include two full-scale preparatory studies, one from the National Gallery of Canada in Ottawa and one from the Herbert and Nell Singer Foundation in New York. It is the first time that these major studies and the Phillips's painting are reunited since they were in Degas's studio. It is also lovely that the first work by Degas that Duncan Phillips acquired, *Ballet Rehearsal* (c. 1885–91), returns to The Phillips Collection for the first time since Phillips gave it to his alma mater, Yale University, in 1952.

We are extremely grateful to Chief Curator Eliza Rathbone and Head of Conservation Elizabeth Steele for their dedication to the careful scholarly and creative collaboration that engendered and characterizes this beautiful exhibition and publication. Their work, and the contributions of their colleagues who collaborated on this project, offers us precious insights into Degas and his working methods. Revision, repetition, variation on theme, and experimentation in many media—these are characteristics of a modern aesthetic and the basis of our enduring love of Degas's art, as much as the elegant ballet dancers whose grace and agility he captured so fully. Thank you to Shelley Sturman and Daphne Barbour of the National Gallery of Art, Robert Greskovic and Christopher Wheeldon, and Phillips Conservation Fellow Patricia Favero and Paper Conservator Sylvia Albro for their enlightening contributions to this important catalogue. Thank you to Magda Nakassis for editorial work.

Additional thanks to The Phillips Collection staff, including Liza Key, curatorial coordinator; Joseph Holbach, chief registrar; Trish Waters, associate registrar for exhibitions; Gretchen Martin, assistant registrar for visual resources and collection; Vanessa Mallory Kotz, book editor; Ann Greer, director of communications and marketing; Cecilia Wichmann, publicity and marketing manager; Vivian Djen, marketing communications editor; Suzanne Wright, director of education; Brooke Rosenblatt, manager of public programs and in-gallery interpretation; Amanda Jirón-Murphy, in-gallery interpretation and public programs coordinator; Kara Mullins, director of development; Christine Hollins, director of institutional giving; Susan McCullough, director of corporate relations; Allison Chance, director of individual giving; Sue Nichols, chief administrative and financial officer; Cheryl Nichols, director of budgeting and reporting; Jessica Stephens, finance assistant; Darci Vanderhoff, chief information officer; Caroline Mousset, director of music programs; Karen Schneider, librarian; Sarah Osborne-Bender, cataloguing and technical services librarian; Bill Koberg, head of installations; Shelly Wischhusen, chief preparator; Alec MacKaye, preparator; Angela Gillespie, director of human resources; Dan Datlow, director of facilities and security; Tim Wallace, security manager; and Brooke Horne, executive assistant to the director and the board of trustees.

We are extremely grateful to have the support of many generous sponsors whose contributions made this catalogue and exhibition possible. Lockheed Martin has been a stalwart supporter of The Phillips Collection for many years. Their recognition of art as a powerful vehicle for inspiring and nurturing creativity and innovation, not just within their company but also across the country, is matched only by their leadership and dedication to supporting art and education in the communities in which their employees live and work. We are also delighted to welcome Pernod Ricard, a new partner that has its own impressive tradition of supporting artistic expression and encouraging contemporary art. Finally, we are grateful to Perry and Euretta Rathbone who devoted their lives to the public appreciation of art. We celebrate their lives and important legacy.

Dorothy Kosinski
Director

LENDERS TO THE EXHIBITION

The British Museum, London

Corcoran Gallery of Art, Washington, D.C.

Dixon Gallery and Gardens, Memphis

Fogg Museum, Harvard Art Museums, Cambridge

Herbert and Nell Singer Foundation, Inc., New York

Hirshhorn Museum and Sculpture Garden,
Smithsonian Institution, Washington, D.C.

The Metropolitan Museum of Art, New York

Museum of Fine Arts, Boston

National Gallery of Canada, Ottawa

National Museum of Art, Architecture and Design, Oslo

Ny Carlsberg Glyptotek, Copenhagen

Paul and Natalie Abrams

The Morgan Library and Museum, New York

Philadelphia Museum of Art

Private Collection

Private Collection, Courtesy of Sotheby's, New York

Private Collection, London, Courtesy of Connaught Brown, London

Solomon R. Guggenheim Museum, New York

Yale University Art Gallery, New Haven

INTRODUCTION AND ACKNOWLEDGMENTS

Every exhibition of Edgar Degas's work ultimately deals with the artist's process. Whether or not the organizer intends to focus on the complex interrelationships that exist between one work by Degas and another or seeks to reveal the secrets of his wide range of materials and techniques, the work of Degas will ultimately engage, puzzle, and amaze anyone who attempts to establish sequences of execution or fully fathom the intricately related "experiments" of this profound creative genius. Having worked on Degas for decades, Jean Sutherland Boggs still declared him an enigma who remained "elusive." George Shackelford who organized *Degas: The Dancers* at the National Gallery of Art in 1984, noted that his exhibition was first about Degas's treatment of this central subject of his career, but second about process and the "reevaluation of Degas's working methods." Scholars Theodore Reff, Henri Loyrette, Gary Tinterow, Richard Thomson, Richard Kendall, and Jill DeVonyar, among others, have contributed prodigiously to the vast literature on the artist, all offering valuable insights while seeking a deeper understanding of this restless polymath.

Also noteworthy for their focus on Degas's methods is the publication in 1945 of Denis Rouart's *Degas: In Search of His Technique,* and, more recently, the National Gallery, London's *Art in the Making: Degas.* The bibliography at the end of this publication is intended to direct the reader to these and additional sources for further reading, among them the landmark catalogue for the retrospective organized by the Metropolitan Museum of Art in 1989, which remains to this day perhaps the single most valuable publication on the artist. Richard Kendall and Jill DeVonyar's many publications accompanying numerous exhibitions have further investigated hitherto unexplored territory. The exhibition they have organized for the Royal Academy of Arts in London that is concurrent with ours at The Phillips Collection has challenged our efforts to borrow works not already spoken for by their much larger show. We have all learned from their studies of Degas, most especially from

their exploration of Degas's relationship to the art of ballet. To all the above we are indebted.

This book commemorates a small show that was inspired by a study of Degas's process. Exciting discoveries were made in the conservation studio when Degas's great late painting *Dancers at the Barre* was examined and treated for the first time since it was acquired by Duncan Phillips in 1944. To put the painting into a larger context, we borrowed pieces from international collections to elucidate Degas's treatment of the theme of ballet, the subject to which he devoted more works than any other. In the process we conducted extensive research to locate directly related studies for *Dancers at the Barre* as well as other works thematically or technically related to it. In this exhibition, we hope to suggest through approximately thirty closely related examples of Degas's work something of the complexity of the artist's process and its evolution over his long and prolific career. This is the first time since the exhibition at the Metropolitan Museum of Art in 1989 that The Phillips Collection's *Dancers at the Barre* is shown alongside the large-scale pastel in the collection of the National Gallery of Canada; we are deeply grateful for this opportunity to bring these works together. We are also extremely thankful to Yale University Art Gallery for allowing the painting given to them by Duncan Phillips in 1952 to return to The Phillips Collection; this is the first exhibition to celebrate the exceptional group of works by Degas chosen by Duncan Phillips for his museum.

Because of the critical role of sculpture in the work of the artist, we are fortunate that two renowned experts on this subject are here in Washington, D.C., and have contributed an essay to this publication: National Gallery of Art object conservators Shelley Sturman and Daphne Barbour. Most thrilling too has been the participation of dancer-choreographer Christopher Wheeldon in the form of an interview conducted by Robert Greskovic, dance critic for the *Wall Street Journal* and author of *Ballet 101: A Complete Guide to Learning and Loving Ballet*. Wheeldon's insights bring to life Degas's works in an entirely fresh way. I am grateful to *The Washington Post* dance critic Sarah Kaufman and dance critic and historian Alexandra Tomalonis of the Kirov Academy of Ballet here in Washington for their encouragement and suggestions. Without them this interview might not have happened.

My colleague, Elizabeth Steele, and I would also like to acknowledge and thank the following individuals for their help in myriad ways

to advance our project. At the Museum of Fine Arts, Boston, George Shackelford and Clifford Ackley; at the Corcoran Gallery of Art, Dare Myers Hartwell and Philip Brookman; at the National Gallery of Art, Barbara Berrie, Ann Hoenigswald, and Greg Jeckman; at the Fogg Museum, Emily Hankle; at the Ny Carlsberg Glyptotek, Line Clausen Pederson; formerly at the National Gallery of Canada, David Franklin; at the Library and Archives of Canada, Anne Maheux; at the Philadelphia Museum of Art, Joeseph Rishel and Inness Shoemaker; at Sotheby's, Jason Herrick, Jill McLennon, Jennifer Raleigh, Deborah Robinson, and Claudia Hamilton; at Christie's, Jessica Fertig; at Connaught Brown Gallery, Anthony Brown; for the Herbert and Nell Singer Foundation, Jay Sendak; and at Yale University Art Gallery, Patricia Garland.

At The Phillips Collection, my interns, Genevieve Hulley, Alexandra Morrison, Catherine Ross, and Lia Dawley have all contributed with enthusiasm to this project. Lia, who came for the final phase of preparation, was a true godsend. For her attention to detail and bright spirit, I am forever grateful. In addition I am grateful to Daniel Yett for volunteering his efforts on numerous fronts. In conservation at the Phillips, Patricia Favero, Sylvia Albro, Caroline Danforth, and Juan Tejador have generously contributed their time and expertise, along with Val Lewton, designer; Trish Waters, associate registrar; Bill Koberg, Shelley Wischhusen, and Alec MacKaye, preparators; Karen Schneider, librarian; and Vanessa Mallory Kotz and Vivian Djen, editors. Thank you to Claude Skelton for a beautiful catalogue design. Liza Key, curatorial coordinator, has assisted in all aspects of the exhibition and publication. In other important ways, I am also especially thankful to Gretchen Martin, assistant registrar, and Elizabeth Easton. Finally I am grateful for the lifelong support and encouragement of my parents, whose gift to The Phillips Collection happened to arrive just in time to support this unique and rewarding project.

Eliza Rathbone
Chief Curator

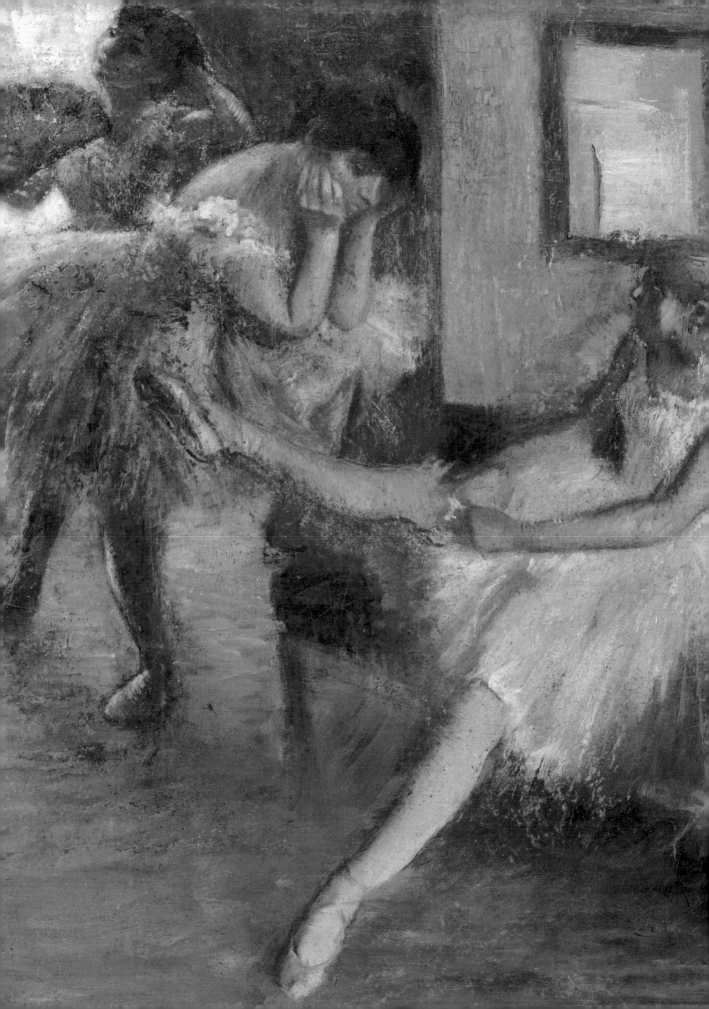

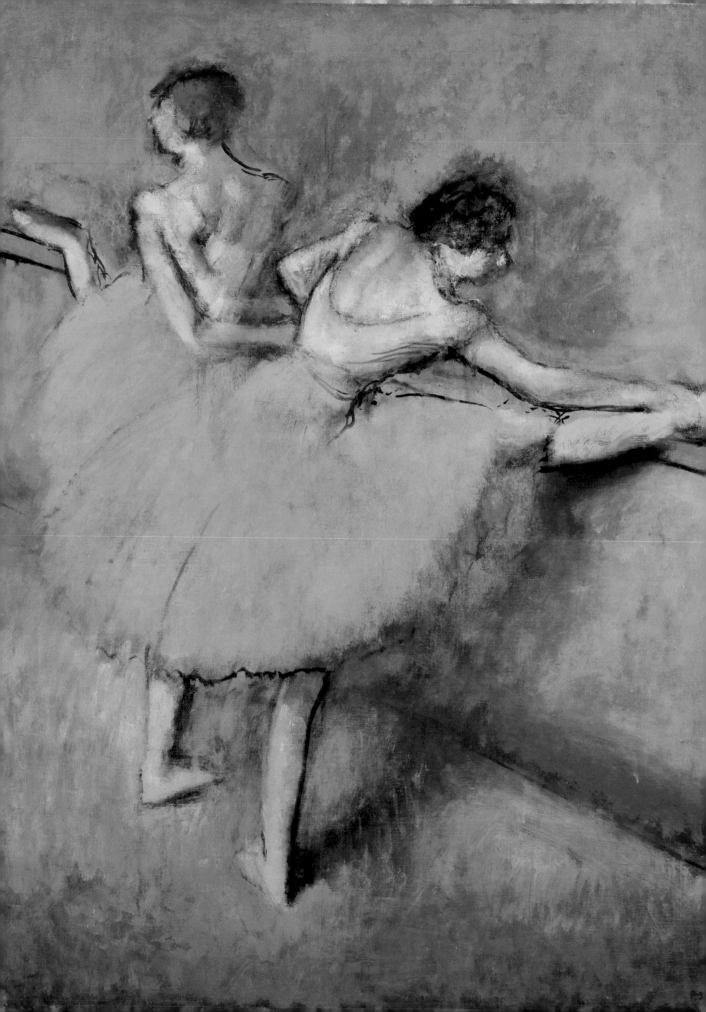

DEGAS'S DANCERS AT THE BARRE
YEARS IN THE MAKING

ELIZA RATHBONE

"Of all impossible things in this world to treat artistically the ballet girl seemed the most impossible, but Degas accomplished that feat." [1]

GEORGE MOORE,
MEMORIES OF DEGAS, 1918

"But it is essential to do the same subject over again, ten times, a hundred times. Nothing in art must seem to be chance, not even movement." [2]

EDGAR DEGAS, 1886

[CAT. 1]
Dancers at the Barre,
Early 1880s–c.1900
Oil on canvas
51 1/4 x 38 1/2 in.

uring the early 1880s, Edgar Degas set out to compose his first large-scale painting of two dancers at the barre. Already highly regarded by fellow artists and critics alike, Degas not only had shown his work at the Salon, but also had joined the group of independent artists, who became the impressionists. He helped organize their exhibitions, starting with the first of eight in 1874. By 1880 he was known both as a "painter of dancers" and "a painter of movement." In a review of works shown at the fifth impressionist exhibition that year, Charles Ephrussi, the influential critic and publisher of the *Gazette des Beaux Arts,* further described Degas as having a "well-known predilection for choreographic subjects." Another critic stated, "Degas continues to be passionately devoted to movement," and another concluded, "Degas remains the indisputable and undisputed master. With his truly admirable sense of movement..." [3] That dance and movement are indivisible from one another goes without saying, but Degas succeeded in conveying both the discipline and the movement of the dancer to unparalleled effect.

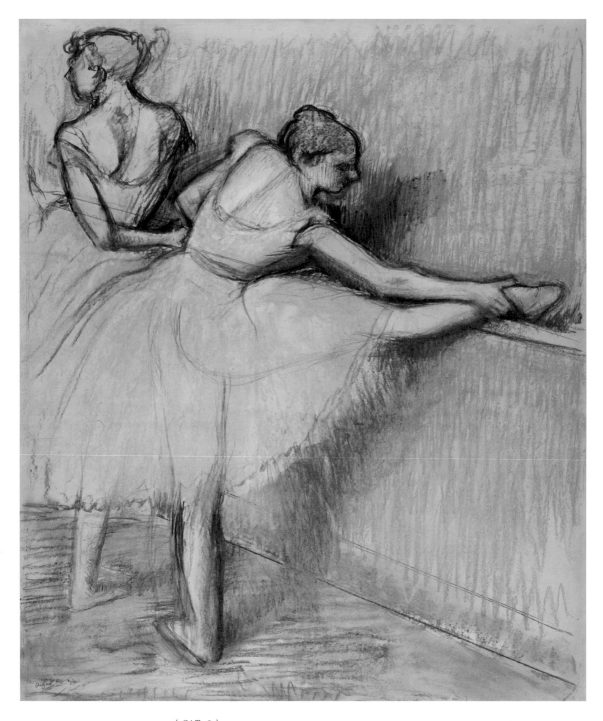

[CAT. 2]
Dancers at the Barre
c. 1900
Charcoal and pastel on
tracing paper, laid down
on cardboard
49 ¹/₄ x 42 ¹/₈ in.

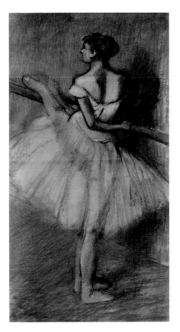

[FIG. 1]
Dancer at the Barre
1884–88
Pastel on paper
43 $^{1}/_{3}$ x 24 $^{2}/_{5}$ in.

No other artist has explored the world of ballet with so complete or sustained a passion. Degas famously explained his interest in the subject, saying, "Because only there can I recapture the movements of the Greeks."[4] Degas devoted much of the 1870s to observing dancers in the classroom, as well as on the stage. He knew individual dancers as well as ballet masters; he loved to sing and grew up in a house filled with music.[5] In Paris, Degas frequented the old opera house on the rue Le Peletier and the new one, the Palais Garnier—both a relatively short walk from the Montmartre addresses where he lived. In dance Degas found an extraordinary vocabulary of movement. As in some other subjects he took from contemporary society (milliners and laundresses, for example), he emphasized the work that underlies the dancer's art. He captured all aspects of dance: the grittiness and physical effort, the discipline, the rote and repetition. These practices so integral to ballet

[FIG. 2]
*Dancers Practicing
at the Barre*
1877
Mixed media on canvas
29 $^{3}/_{4}$ x 32 in.

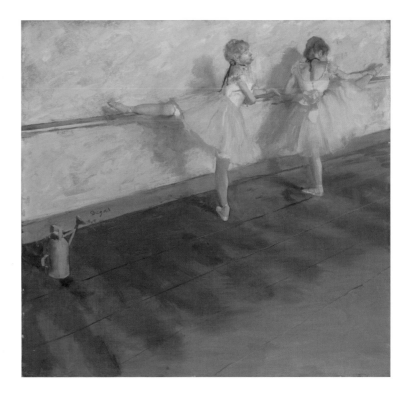

are manifested in his work to such a degree that he himself resembles a choreographer, keenly aware of the artifice and reality involved in both. Rhythm and repetition, repetition and variation, point and counterpoint are at the core of the discipline of ballet and equally informed and permeated Degas's own work.

During the 1870s, Degas created his first iteration of two dancers exercising at the barre (fig. 2), a painting he exhibited in the third impressionist exhibition of 1877.[6] Already visible in this initial work are key aspects of the larger painting he began in the early 1880s and revised around 1900 (cat. 1). In the earlier work, one dancer extends her right leg on the barre in front of her while the other extends her right leg behind her, their splayed positions creating a radial symmetry. The space—devoid of other dancers—is made dynamic by the diagonal of the barre itself, echoed in the floorboards and dramatized by their attenuated postures. In his larger composition, Degas devised a new placement of the two dancers in which they mirror each other's position. They face in opposite directions and are so close to each other that their skirts fuse into one. The space of the room is now reduced, bringing the viewer closer to the subject. To achieve this composition, Degas made numerous studies—at least six of them on a large scale—including studies of each dancer individually, of each figure in the nude, and at least three large drawings of the composition combining the two dancers (cats. 2 and 3, figs. 1 and 3).[7] Although a sequence has never been established for these drawings, they date from the 1880s to c. 1900. In most respects, Degas's painting of dancers exercising at the barre from the 1870s and the finished piece completed around 1900 offer the viewer dramatically different experiences.

While Degas may have begun The Phillips Collection's *Dancers at the Barre* before 1884, he significantly altered its appearance around 1900. Although he devoted much of the 1870s to the subject of ballet, he had just started the years of work and experimentation that eventually would lead to this late masterpiece. It was one of countless works of art found in Degas's studio after he died. In 1897 he made his penultimate residence on the rue Victor Massé, in a large building where he expanded his quarters to encompass several floors, with different spaces devoted to various aspects of his life and work: studio, living and dining, and his ever-growing collection of works by other artists. Here Degas returned to some of his earlier works dating from the 1870s and 1880s. Why, since his paintings from these decades were so admired and had sold well to important collectors, did he decide to revise them, including the *Dancers at the Barre*?

Not only did Degas compulsively revise his work, but he also continually invented new approaches and techniques. His exploration of widely diverse media and his disinclination to date his work, or to consider

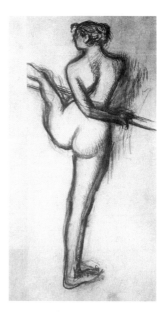

[FIG. 3]
*Nude Study for Dancer
at the Barre*
c. 1895–1900
Charcoal on paper

[CAT. 3]
*Study of a Nude
Dancer at the Barre*
1895–98
Pastel and charcoal on
paper, laid down
on board
46 7/8 x 33 7/8 in.

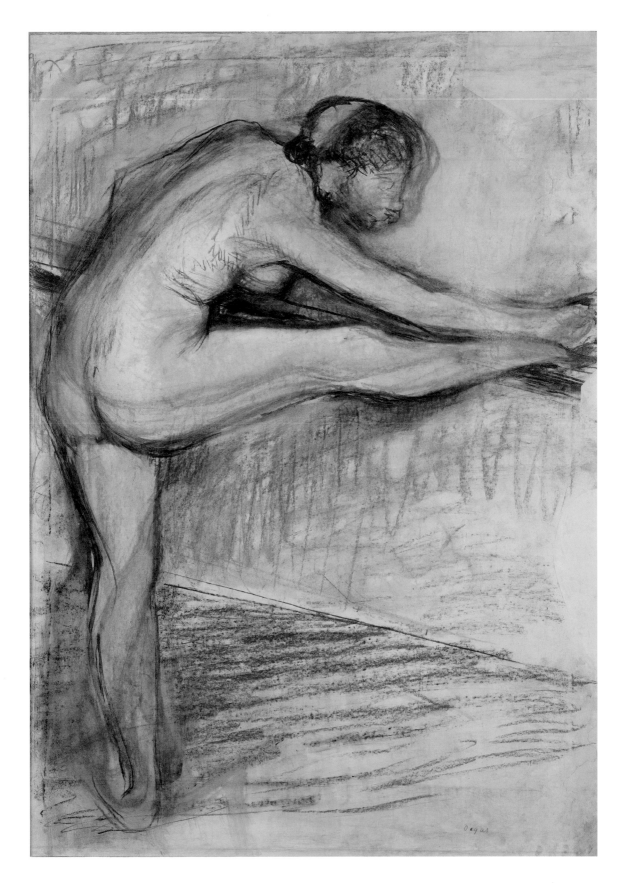

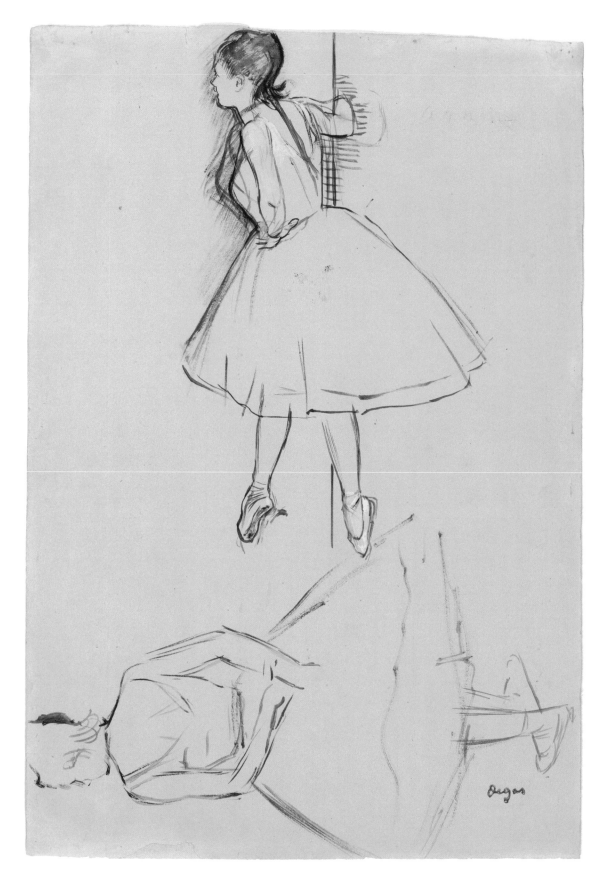

any investigation complete, contribute to the complex evolution of his oeuvre. Repeating himself and copying the work of others were central to his method from his early years. That he looked to and absorbed the lessons of his predecessors—from antiquity to the Renaissance, as well as more recent giants such as Jean-Auguste-Dominique Ingres and Eugène Delacroix—only fueled his creative impulse. As Theodore Reff has shown, Degas practiced composing with figures from multiple sources, beginning early with the painting *Daughter of Jephthah* (c. 1859–61). His models are plucked from the Parthenon, Andrea Mantegna, and Frans Snyders, and he mingled his copies from painting and sculpture into a single new composition.[8] In Rome, where he spent formative years as a young man (1856–60), he was constantly in the company of Gustave Moreau, who made a frequent practice of tracing and could indeed have introduced Degas to this approach.[9] Tracing the work of others as well as his own, including using tracing paper to reverse images, became a critical tool for the artist who often repeated a figure from one composition to another. Degas may well have been aware of such a practice of quoting and recomposing, prominent among the artistic forebears he most admired. Ingres used tracing and Delacroix advised his students to copy, saying of Raphael that his originality was at its liveliest when he was borrowing ideas from other artists.[10] This may also be said of Degas, whose artistic influences range from antiquity to the satirical images of Honoré Daumier. His copies and tracings, rather than derivative or slavish, instead informed his own freedom to invent, and his determination to create an art of his own time led to one of its most sharp and observant eyes. Having taken two of the era's greatest draftsmen, Ingres and Daumier, as inspiration early in his career, Degas increasingly turned late in his life to two great colorists, Delacroix and Titian, as he evolved from a keen observer of the social conditions of his time to a more reclusive master intent on realizing the timeless essence of his art.[11]

While steeped in examples from the past, Degas invented new means of expressing his world. Reff likens Degas's studio to "a kind of attic laboratory."[12] Here he engaged in a range of media and techniques while transforming and adapting them to new ends; many works were executed in combined media that only recent scientific analysis has been able to identify.[13] He began using pastel around 1860 and was exploring lithography and monotype in the 1870s, while at the same time making his first sculptures. These diverse media became increasingly

[CAT. 4]
*Two Studies of a
Ballet Dancer*
c. 1873
Brush and brown ink,
heightened with white,
on pink paper, now faded
16 1/16 x 11 1/16 in.

interrelated as the artist's drawings, sculptures, and prints served as studies for one another, developing a richly cross-pollinating process. The proofs and counterproofs he made from his charcoal and pastel drawings have been described at length in recent literature. Of his nearly seven hundred works in pastel, roughly one hundred were done on top of monotypes. Many prints were made for pure experimentation, not to be shown. Similarly, his sculpture may be best understood as further research into anatomy and as three-dimensional studies critical to the advancement of his work. By the 1890s, Degas had, in the multimedia laboratory that was his studio, numerous sculptures in wax, plaster, and other materials[14] as well as prints, drawings, paintings, and pastels. Degas's impaired eyesight at this time did nothing to dampen his impulse to adapt and transfer methods and tools from one medium to another, and to invent unprecedented, wholly original techniques.

[CAT. 4]
Two Studies of a
Ballet Dancer
(detail)

REPETITION AND VARIATION ON A THEME: BALLET REHEARSALS AND THE SEARCH FOR NEW COMPOSITIONS

At the third impressionist exhibition of 1877, in addition to *Dancers Practicing at the Barre* (1877) (fig. 2), Degas exhibited two other paintings from the 1870s that featured dancers in the classroom. In both paintings, *Dance Rehearsal* (1873) (cat. 5) and *The Dance Class* (c. 1873) (cat. 6), the artist demonstrates his interest in the effect of daylight, a concern he shared with the impressionists. While they mostly explored outdoor scenes, Degas illuminates the interior space of a classroom flooded with daylight through tall arched windows. The quality of this indoor light is subtly observed and sometimes specific to a particular time of day. So engaged did Degas become in the manipulation of these spaces, based on the practice room at the old Opéra on the rue Le Peletier, that he continued to use it as a setting for his paintings even after the building burned down in 1873.[15] The two paintings reveal opposite aspects of his approach to such scenes—the one nearly *grisaille,* in a subdued palette that he often used to begin a work, and the other enlivened by vivid color accents. In the first, he pared the scene to an essential moment in time when the instructor demonstrates a step to his pupil, tilting his body backward with his arms raised, forming arcs above his head. In the center of the composition, a dancer, who supports herself with one hand on a pillar, observes the step taking place. *Two*

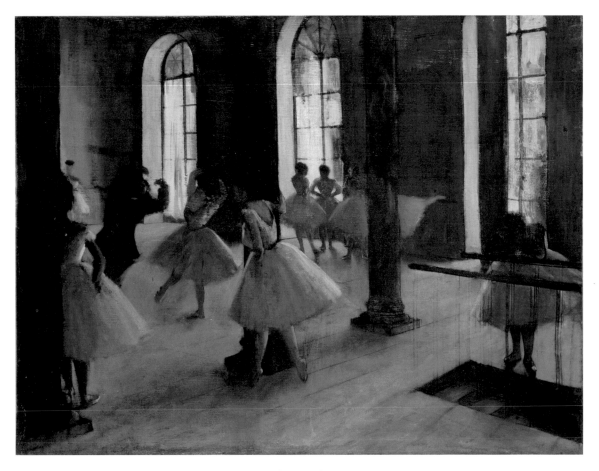

[CAT. 5]
Dance Rehearsal
1873
Oil on canvas
16 x 21 $^5/_{16}$ in.

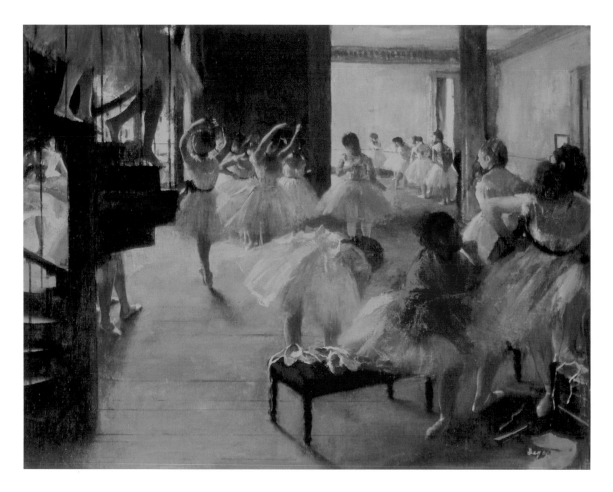

[CAT. 6]
The Dance Class
c. 1873
Oil on canvas
18 ³/₄ x 24 ½ in.

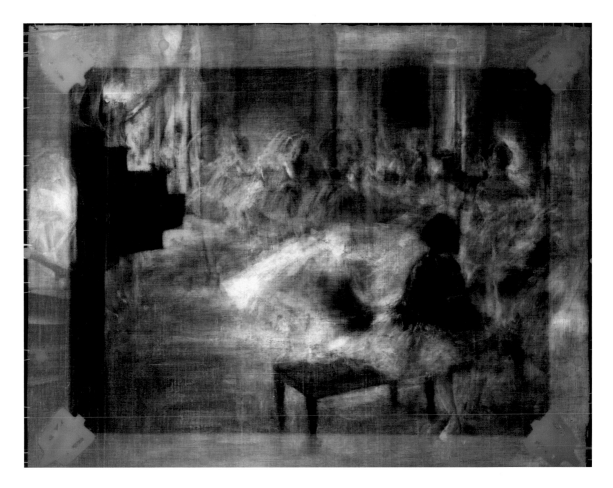

[FIG. 4]
The x-radiograph of
The Dance Class
shows that the dancer
seated on the bench
held a paper in her right
hand and her left arm
was down. Degas had
also originally included
a dance master standing
to the right behind her.

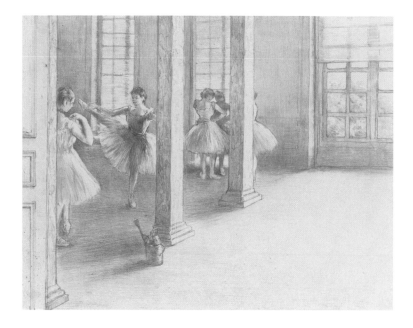

[FIG. 5]
George William Thornley
The Dance Class
c.1888
Lithograph
9 ³/₈ x 12 ¹/₈ in.
Private Collection

Studies of a Ballet Dancer (c. 1873) (cat. 4) offers insight into Degas's method of combining specifically observed individual poses in a single composition, including a study for this dancer as well as a separate study of a second dancer with her arms behind her back, silhouetted *contre-jour* in front of the window.

Far more complex and colorful is *The Dance Class* (cat. 6), a work believed to include references to a greater number of dancers than any other single work in Degas's career. In a composition including four groups of six dancers, Degas has invented a scene both spatially complex and diverse in the poses and activities of the figures. An effect of spontaneity is achieved through their apparently random simultaneous actions; within the groups some interaction takes place as it does in *Two Dancers* (1873) (cat. 8), a study of two figures facing each other, mirroring one another's gestures and evoking the reflected images of dancers that is a feature of the ballet classroom. By cropping his composition in such a way as to slice a figure in half or reveal the play of multiple pairs of legs as they descend a circular staircase, Degas effectively gives the impression of movement, both on the part of the viewer as well as the viewed. Though hardly achieved in an instant, it suggests a fleeting moment in time that came to be associated with the photograph, the very essence of modern experience. Indeed Degas's experiments with rendering movement anticipate his great interest later

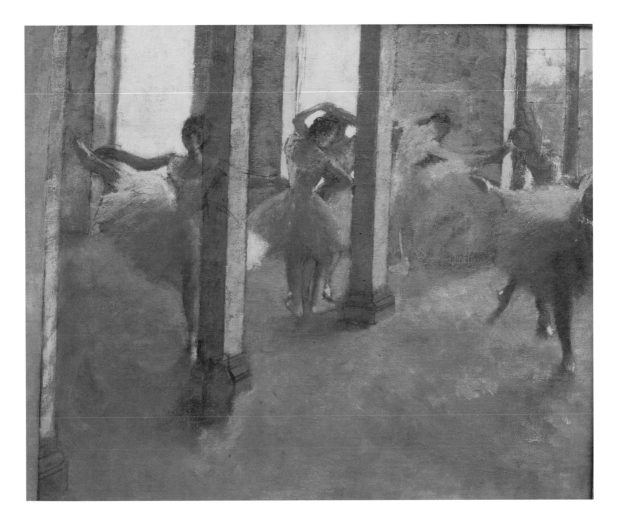

[CAT. 7]
Dancers Practicing
in the Foyer
1875–1900
Oil on canvas
28 x 34 ⁵/₈ in.

in the decade in the work of Eadweard Muybridge, as well as his own experiments with the camera. Just as he later revised *Dancers at the Barre,* so in these two works do we see his irresistible urge to improve upon his ideas. When examined through x-radiography and infrared reflectography, both works show revision, the first painted over a portrait (p. 116) and the second involving complex reworking of the figures in the scene (fig. 4). While begun around 1873, it seems likely that Degas made his changes to *The Dance Class* later in the 1870s. Here the dancer seated on a bench in the foreground originally looked straight ahead, with her hands in her lap holding a piece of paper. Behind her, to the right, Degas once included the dance master, a figure he subsequently painted out and replaced with a column and a dancer standing to the right of it. Replacing the *repoussoir* (as Edmond de Goncourt would call it, see below) of the dance master, this architectural element makes a pictorial transition to the deep space of the room beyond, where another group of dancers gathers. Moreover, echoing *Dance Rehearsal* (cat. 5), the painting appears to originally have had three windows, while possibly not the circular stairs. This ingenious device was quite probably the artist's invention, for which he used a wooden model in his studio.[16] The peach-colored sash in the bottom-right corner, a brilliant color note, must have been added late since it obscures the "s" of Degas's signature. Often paired with the painting *The Rehearsal* in the Burrell Collection, Glasgow, which also features the circular stairs, the two works together exemplify Degas's creative engineering of the space his dancers occupy. Quite likely remarking on an earlier state of *The Dance Class* during a visit to Degas's studio in February 1874, Edmond de Goncourt described in his journal:

Then the dancers come in. It's the rehearsal room, with the fantastic silhouette of the dancers' legs descending a little staircase seen against the light from a window; and with the bright red patch of a tartan amid all these puffy white clouds, and the rascally repoussoir *of a ridiculous ballet master. And before our eyes, caught in the act, the charming twists and turns of these little monkey-girls. The painter shows us his pictures, occasionally illustrating his commentary by miming a choreographic gesture, by mimicking—to use the expression of the dancers themselves—one of their arabesques. And it is really very entertaining to see him, on his toes, his arms curved, mingling the aesthetics of the ballet master with those of the painter…. An original fellow, this Degas…*[17]

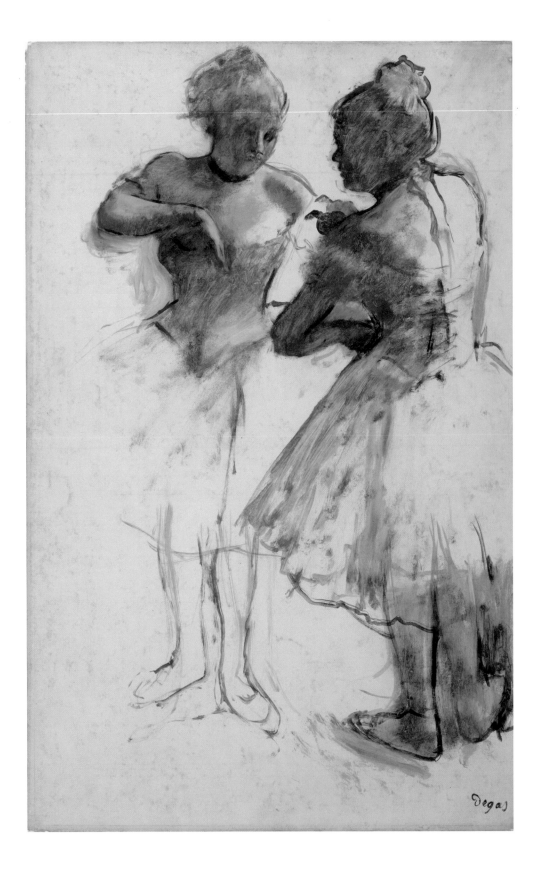

Since both *Dance Rehearsal* and *The Dance Class* found a buyer, they escaped later revision in Degas's studio. Both paintings are believed to have been owned in the late 1870s by British collector Henry Hill of Brighton, who loaned *The Dance Class* to the third impressionist exhibition in 1877. Also from this period comes a closely related, somewhat larger painting of dancers in the classroom that remained in Degas's hands. Because, like *Dancers at the Barre,* it was still in Degas's studio at the rue Victor Massé, he repainted it around 1900. The only record of its appearance in the 1870s is in an unpublished print by George William Thornley (fig. 5). The revised *Dancers Practicing in the Foyer* (1875–1900) (cat. 7) shares with The Phillips Collection's *Dancers at the Barre* an intense and fiery palette and a blurring of the dancers' contours.[18] In all these paintings of the 1870s, consistent with the first *Dancers Practicing at the Barre* (fig. 2), the diagonal plays a critical role in the composition, whether through architectural elements or an arrangement of the dancers themselves; it lends dynamism to a scene suggesting imminent movement across the open space of a room.

SEQUENCES IN TIME AND SPACE: THE FRIEZE PAINTINGS

Starting in about 1879, Degas began to create a series of works in an elongated format (all approximately twice as wide as they are high). This format so engaged him that he returned to it repeatedly, the latest of these forty-some works dating to after 1900. Regarding ballet subjects alone, Richard Kendall accounts for ten works in oil and ten in charcoal or pastel, and he notes that Degas made "well over a hundred preparatory drawings for individual figures."[19] Of these so-called "frieze paintings," *The Dance Lesson* (fig. 6), once in the collection of Mr. and Mrs. Paul Mellon, is considered the first.[20] Here, the dancers, rather than practicing, are at rest in various poses, whether seated or standing, and placed on a diagonal that stretches back into the expanding space of the room on the right. With its floor-length windows, the space resembles the classroom at the old opera house. In choosing the painting's elongated format, Degas discovered that it suited his ongoing investigation of groupings and intervals, to which the subject of dancers was so ideally suited. That he found inspiration for these elongated works in Japanese prints, scrolls, and screens is quite possible, just as he exploited in numerous examples the compositional challenges of the

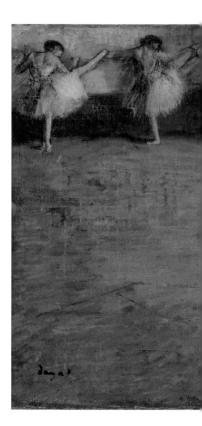

[CAT. 9]
Ballet Rehearsal
c. 1885–91
Oil on canvas
18 7/8 x 34 5/8 in.

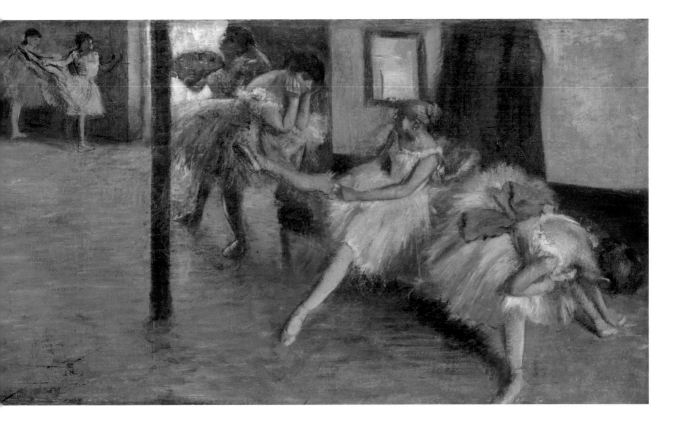

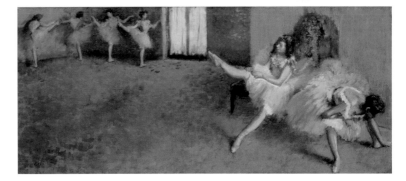

[FIG. 6]
The Dance Lesson
c. 1879
Oil on canvas
14 $^{15}/_{16}$ x 34 $^{5}/_{8}$ in.

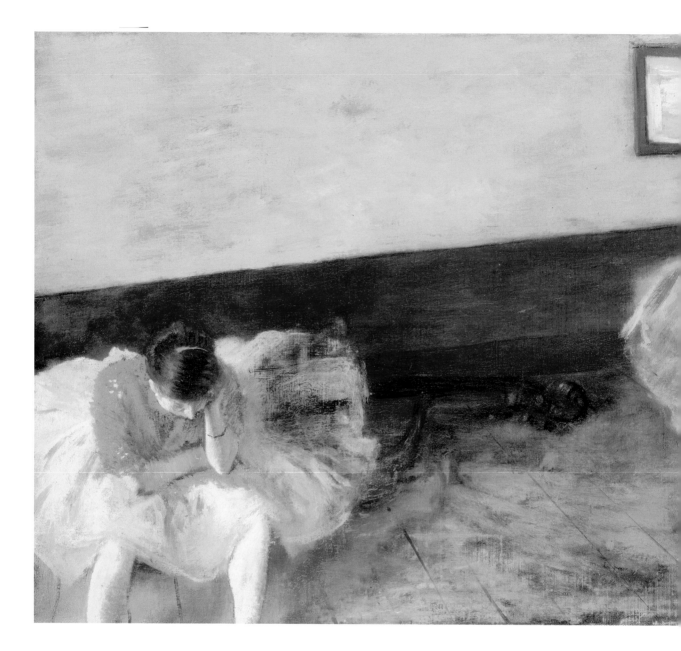

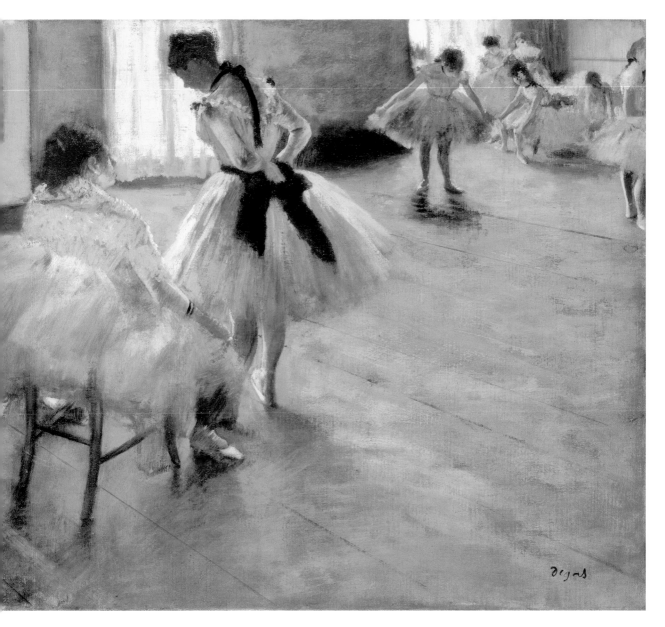

[FIG. 7]
Before the Ballet
1890/92
Oil on canvas
15 ³/₄ x 35 in.

[CAT. 11]
Nude Study–
Two Dancers Seated
c. 1880
Charcoal on paper
13 ¹/₄ x 18 ³/₈ in.

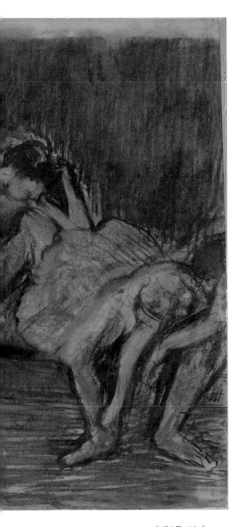

[CAT. 10]
Dancers in the
Rehearsal Room
1900–1905
Charcoal with pastel
on paper mounted
on cardboard
17 ⁷/₈ x 33 ¹/₂ in.

shape of a fan. Equally valid is the possibility of a model from ancient Greek architectural relief.

Certainly these works, with their horizontal extension and their variations on a theme of dancers at intervals in space, evoke a temporal sequence, a movement in time and space. Like *The Dance Lesson,* Yale University's *Ballet Rehearsal* (c. 1885–91) (cat. 9) includes a notice board on the wall, close to the center of the composition. In most other respects, it more closely resembles paintings in the Sterling and Francine Clark Art Institute (*The Dancing Lesson*) and the National Gallery of Art (*Before the Ballet,* fig. 7) in which a register of dancers at the barre acts as a horizontal frieze on the left and is offset by the diagonal of the bench where dancers are arrayed in the foreground. These dancers at the barre appear and reappear, like a refrain, in compositions where the seemingly episodic placement of dancers, alone or in groups, takes on an increasingly abstract quality, with less and less to do with creating a convincing scene from life. While in the earliest of these scenes Degas still defines the floor (even using a straight edge for the floorboards) and the light coming into the room, in later or repainted examples he tends to reduce the number of windows and figures and to integrate the empty space of the floor into an overall more loosely painted surface. Increasingly, the relative scale and placement of the dancers themselves define the space. X-radiography of the Yale painting reveals numerous changes, including the elimination of a stool or dancer in the left foreground, as well as many adjustments to positions of legs. In both the Yale painting and a much later work in charcoal and pastel, *Dancers in the Rehearsal Room* (1900–1905) (cat. 10), Degas employs the central column—no longer a prop for a dancer to hold as in *Dance Rehearsal* (cat. 5)—as a compositional device that both anchors and divides his composition and reinforces the architecture, which has become increasingly undefined. By partially obscuring a figure or her skirt, the vertical adds to a sense of movement past this emphatically stationary element. *Dancers in the Rehearsal Room* is one of numerous examples that includes this pictorial device and attests to Degas's return to the frieze format even after 1900.[21] In this late iteration of the idea, the contours of the figures are blurred, suggesting their perpetual motion, a movement enhanced by the horizontal framing of the scene.

Closely related to the Yale painting, an exceptional drawing, *Nude Study—Two Dancers Seated* (cat. 11), demonstrates Degas's tendency to study the model nude as well as clothed, a practice he never gave

[CAT. 12]
Dancer Adjusting
Her Shoe
1885
Pastel on paper
19 x 24 in.

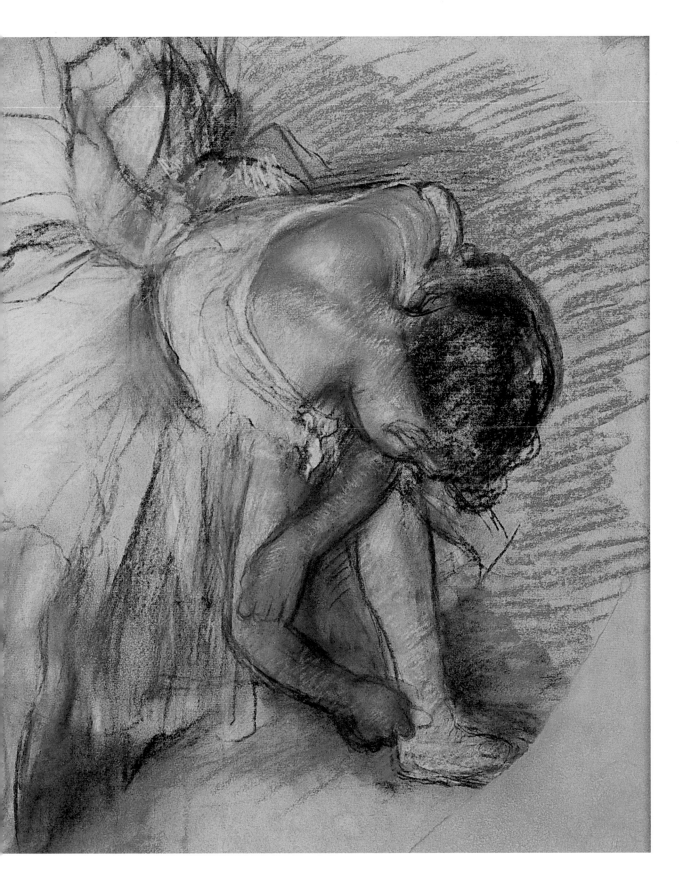

up, although there may have been periods when he pursued it less intensively. Presumably, Degas made this drawing in the course of his work on the painting.[22] The two nude figures, seated on a bench, one tilting back with her right leg raised and the other bending forward toward her left leg, fill the sheet, their heads and toes reaching its borders. The space between the two is perfectly calibrated to create live tension between the figures, whose opposing positions appear to radiate gracefully from the center toward the perimeter of the sheet. Degas had made studies of each position before combining the two in this superb composition. Numerous variations exist for the dancer bending forward. In *Dancer Adjusting Her Shoe* (1885) (cat. 12), her satiny blue sash creates a foil to the stiff tulle of her skirt. Each figure, separately realized, enters the larger composition retaining its integrity as an individual motif. Arranged in a sequence, they suggest elements of a musical composition unfolding over time.

MONOTYPES, PROOFS, AND COUNTERPROOFS

Degas first experimented with monotype in the mid-1870s and soon developed this process to create a wide range of images, most famously his brothel scenes which constitute about one-fifth of his monotype production. He quickly developed this technique to include both a "dark field" and a "light field" approach. Soon he found in monotype an ideal way to begin a work that would continue in pastel. As many as one hundred pastels are believed to be executed over monotypes.[23] Eugenia Parry Janis, a recognized scholar of Degas's work in this medium, interprets his use of monotype as a means of unifying a composition made up of disparate elements or individually studied figures, and maintains that Degas at this point was a "draughtsman learning to paint." Certainly in *Dance Rehearsal* (cat. 5) and other paintings from the 1870s, he showed an inclination to establish his overall composition in *grisaille* before proceeding to a subsequent version in color. In freeing Degas from his natural tendency to draw, the monotype helped him to lay in the essential darks and lights of his composition, which was done in this case by using rags to spread or remove oil from the plate. Occasionally, he even used his fingers. He quickly saw the application of the monotype underlayer for dramatically lit scenes of theater performances. An entire series of pastels from the late 1870s to early 1880s appear to be made in exactly this way, with the

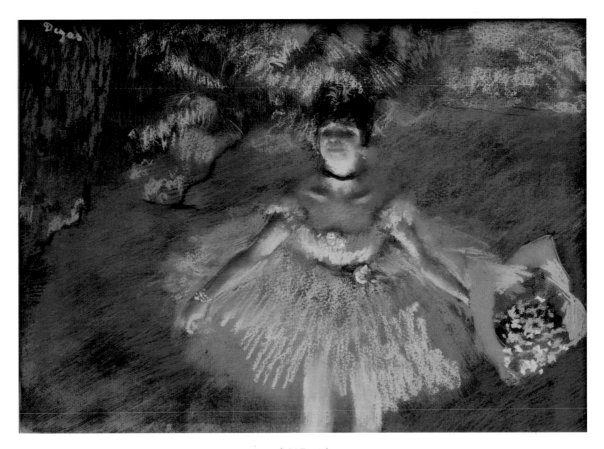

[CAT. 13]
Dancer Onstage
with a Bouquet
c. 1876
Pastel over monotype
on laid paper
10 ⅝ x 14 ⅞ in.

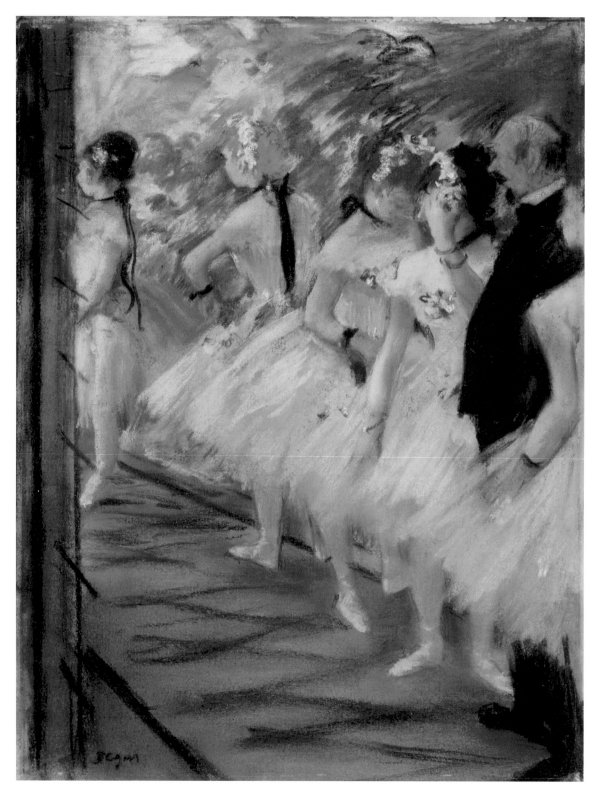

[CAT. 14]
The Ballet
c. 1880
Pastel on light tan laid
paper, mounted on board
12 ³/₄ x 10 in.

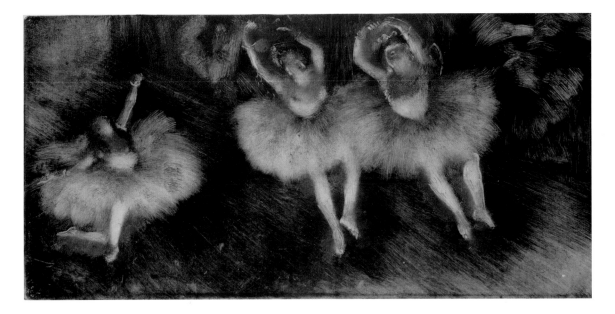

stage lights throwing the face of a dancer, for example, into high relief. Lit from below, her features are cast into a stark contrast of dark and light (cat. 13). These years, clearly ones of intense experimentation, also saw Degas mixing casein, gouache, tempera, and *essence* with pastel, creating works on top of monotypes (cat. 14).[24] But in addition to laying in the darks and lights essential to unifying his composition, surely the monotype propelled Degas forward in his exploration of depicting movement, and as an additional way of freeing the figure from the confines of linear definition. *Three Ballet Dancers* (c. 1878–80) (fig. 8), a monotype in the Clark Art Institute, offers a compellingly vivid depiction of dancers that appear to move before our very eyes.

Degas's work as a printmaker became an obsession; like his work with tracing paper, it allowed him to repeat an image, to reverse it, and, of course, through subsequent states, to revise it, as he famously did in his series of lithographs *After the Bath,* from 1891 to 1892 (cats. 15–18, fig. 9).[25] When a particular pose or pairing of figures showed potential for further development, he often tried it in reverse, as in two works both titled *Two Dancers Resting* (1890–1900 and c. 1890–95) (cats. 19 and 20). In the work from the Philadelphia Museum of Art (cat. 19), Degas appears to have drawn the seated figure in the nude, before summarily suggesting her dancer's attire. A close comparison reveals that the two drawings do not constitute mirror images of each other. The sheets differ in size and the heads of the dancers are closer together in the Philadelphia work. Rather, Degas executes these two works in order to explore and refine all the variables within a given motif. Proofs, counterproofs, and tracings

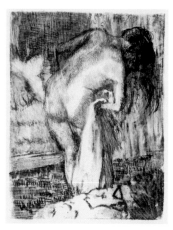

strongly characterize Degas's work of the 1890s.[26] Kendall goes so far as to say, "tracing provided the generating force of his late career."[27]

Over the course of three decades, Degas moved away from composing dancers in expansive interior spaces and toward increasingly close-up views of the dancers themselves. With these subjects, sometimes seen from vertiginous angles, the surrounding architecture fades to near irrelevance. Like a filmmaker zooming in on his subject, he shifted from being an observer of a scene to being virtually in it, and his manipulation of his materials, reflecting this shift, developed an ever-wider range of surfaces and textures. Late in life, Degas's practice of making sculpture also intensified, including modeling directly from the nude. He also applied techniques to his two-dimensional work that directly engaged the physicality of the surface itself. The tools he employed for applying oil paint in his late years, after he had abandoned conventional means, are said by Reff to include "rags, pieces of gauze, blunt and pointed instruments, and his own fingers, with which he could blend two tones to create a distinct

CLOCKWISE FROM TOP LEFT:

[CAT. 15]
After the Bath
1891–92
Lithographic crayon and
graphite, with touches of
black wash on pale pink
Japan transfer paper
13 7/8 x 12 15/16 in.

[FIG. 9]
After the Bath
c. 1891–92
Charcoal on yellow
tracing paper
18 7/8 x 10 in.

[CAT. 16]
After the Bath
1891–92
Lithograph
7 1/2 x 5 3/4 in.

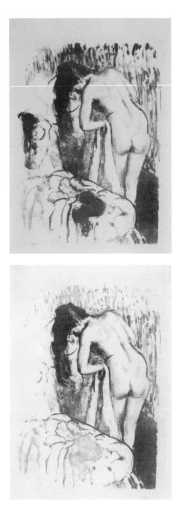

FROM TOP:

[CAT. 17]
Nude Woman Standing,
Drying Herself
1891–92
Lithograph, third state
19 11/16 x 11 1/4 in.

[CAT. 18]
Nude Woman Standing,
Drying Herself
1891–92
Lithograph, sixth state
16 3/4 x 12 in.

texture."[28] And Denis Rouart attests to a late oil of a nude "worked with the thumb." During these years Degas favored pastel over oil paint and looked increasingly to Delacroix and late Titian for inspiration.

In turning to Delacroix and Titian, two of the acknowledged masters of color in the history of painting, Degas revealed his growing concern with color as a vehicle of expression in and of itself. In pastel, he found an ideal medium for combining drawing and color, and for bringing to his work the energy of linear gesture and thus the movement of his subject. At the same time, he brought his experience of monotype, lithography, pastel, drawing, and sculpture to bear on his late paintings, even using his hands to manipulate the medium on the canvas itself. This physical engagement with the surface carried over to painting, from using his fingers making monotypes as well as from modeling with wax.[29] Like *Dancers at the Barre,* other contemporaneous paintings reveal multiple fingerprints as Degas increasingly—like Titian in his late years—physically entered the facture of the painting. Experimental to the end, Degas described his approach to his work: "Fortunately for me I have not found my method; that would only bore me."[30]

In his crowded, dusty studio on the rue Victor Massé, Degas returned to his large canvas of two dancers from the 1880s, *Dancers at the Barre* (cat. 1). He revised it, bringing to the canvas three decades of working on the subject of dancers through printmaking, sculpture, and a growing obsession with pastel (cat. 21). Moreover, he felt compelled to return again to the nude model. In a large-scale study (cat. 3) for the figure on the right of *Dancers at the Barre,* he depicts his model, emphasizing the volume of her limbs, her thighs and her outstretched arms, repeating over and over the contours of her body with the energy and passion of a man who feels the poignancy of his own mortality. Yet having returned to a realistic rendering of her proportions and physicality in his large canvas of the *Dancers at the Barre,* he alters her position and adjusts the placement of her leg to arrive at the artifice at the heart of his work.

Succeeding in bringing to these late paintings a new breadth of treatment, Degas achieved a vibrant palette and a vital and monumental handling of his essential subject, the sort we only see in the late work of great masters—Matisse, Picasso, Rembrandt, Titian. In this grand composition, *Dancers at the Barre,* Degas achieves a unison, a tension, and a perpetual sense of contained energy. In his quest for an art of movement, Degas finds it not only in the asymmetry and disequilibrium of his subjects

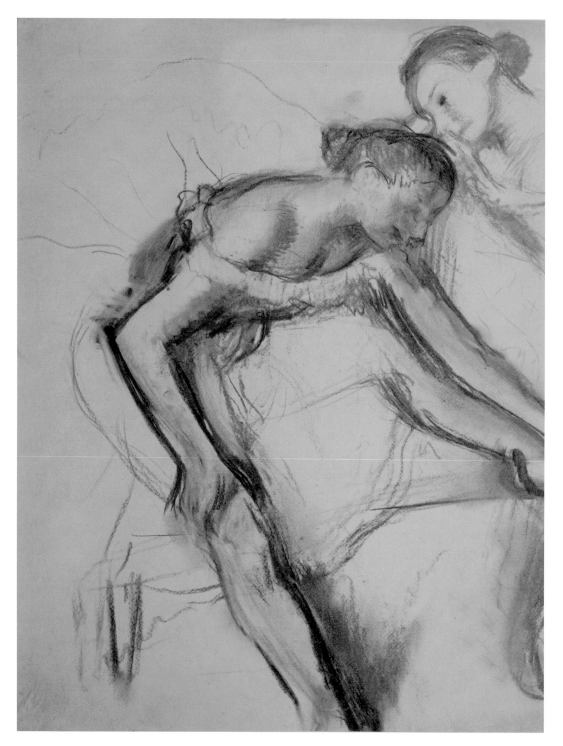

[CAT. 19]
Two Dancers Resting
c. 1890–1900
Charcoal and colored
chalk or pastel on paper
22 ¼ x 17 ½ in.

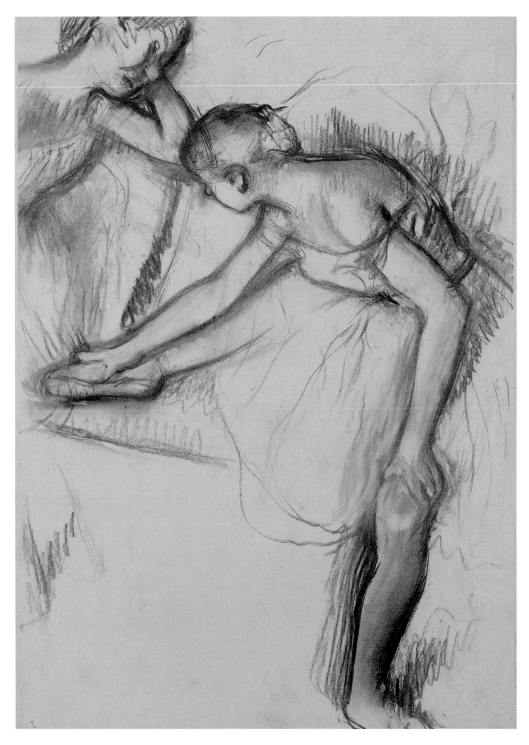

[CAT. 20]
Two Dancers Resting
c. 1890–95
Charcoal on paper
22 ³/₄ x 16 ³/₈ in.

and compositions, but ultimately in his entire approach to making his work. Using his hands to manipulate his medium was only one of the ways in which working in three dimensions informed his work in two dimensions. His increasing interest in sculpture speaks to his continuing desire to explore multiple views—views he had investigated in drawings, for example, of Marie van Goethem. Now in the rue Victor Massé studio, he further develops the idea of circumambulating the figure, realizing that each vantage point for viewing three-dimensionality offers a new, alternate way of seeing and depicting a specific pose in two dimensions. In just such a fashion, the sculpture *Dancer Looking at the Sole of Her Right Foot* (fig. 7, p. 85), a variant of *Dancer Holding Her Right Foot in Her Right Hand* (cat. 23), inspires a myriad of subtly differing images of this pose in two-dimensional works, including *Three Dancers* (c. 1889) (cat. 22). The figure in two-dimensional renderings continues to change and evolve as if from a moving point of view. Just as Degas intended his late landscapes to appear as if seen from the window of a moving train, so in his late pastels of dancers and bathers does he implicate the viewer as well as the viewed, not as a voyeur so much as a participant. In so doing, Degas appears to have opened up the possibility of his own self-expression through the image of the dancer. Having begun by observing the dancer from the outside, he ends his life's work internalizing this chosen vehicle of expression to such a point that it becomes a bearer of his own physical and psychological being. In *Dancers at the Barre*, Degas, the old master and old man, distorts and exaggerates his subject, attenuating their limbs and twisting their bodies into an extreme expression of the rigor and dedication of the discipline that made their art a perfect metaphor for his own.

[1] George Moore, "Memories of Degas (Conclusion)," *The Burlington Magazine* 32, no. 179 (February 1918): 64.

[2] Degas to Albert Bartholomé, 1886, as quoted in English in Clifford S. Ackley, "Edgar Degas: The Painter as Printmaker," in Sue Welsh Reed and Barbara Stern Shapiro, *Edgar Degas: The Painter as Printmaker* (Boston: Museum of Fine Arts, 1984), xii.

[3] De Charry calls Degas "the painter of dancers." See Paul de Charry, *Le Pays* (April 10, 1880); Charles Ephrussi, *Gazette des Beaux Arts* (May 1, 1880); Eugene Veron, *L'Art* (1880); and Armand Silvestre, *La Vie Moderne* (April 24, 1880), as quoted in Charles S. Moffett, Ruth Berson, Barbara Lee Williams, and Fiona E. Wissman, *The New Painting: Impressionism, 1874–1886* (San Francisco: Fine Arts Museums of San Francisco, 1986): 322–23.

[4] Degas quoted by René Gimpel, *Journal d'un collectionneur, marchand de tableaux* (Paris: Calmann-Lévy, 1963), 186. Jean Sutherland Boggs et al., *Degas* (New York: Metropolitan Museum of Art, 1988), 28–29, no. 45.

[5] "Degas, whose voice was *douce et expressive*, loved to sing, particularly opera and, it seems, especially refrains, stimulating himself with singing at work." Mari Kálmán Meller, "Exercises in and around Degas's Classrooms: Part I," *The Burlington Magazine* 130, no. 1020 (March 1988): 209.

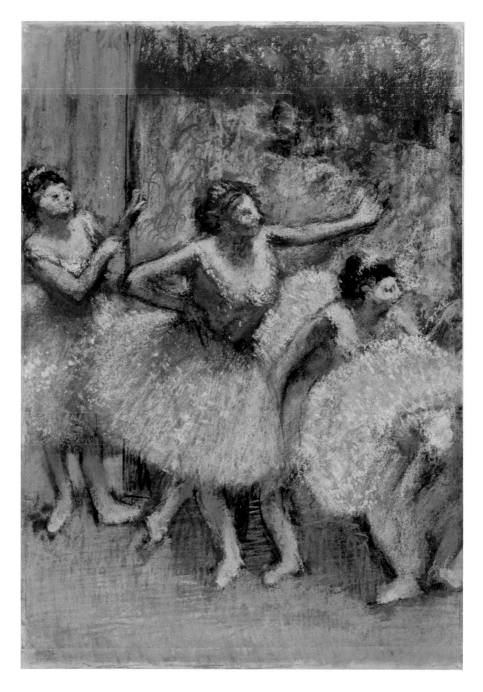

[CAT. 21]
*Dancers in Green
and Yellow*
c. 1903
Pastel on several
pieces of tracing paper,
mounted on board
38 ⁷/₈ x 28 ¹/₈ in.

[6] Moffett et al., *The New Painting: Impressionism, 1874–1886,* 217. Boggs et al., *Degas,* 278.

[7] Paul-André Lemoisne, *Degas et son œuvre* (New York: Garland Publishing, 1984), 3: 460–61, nos. 808–10.

[8] Theodore Reff, "Degas's Copies of Older Art," *The Burlington Magazine* 105, no. 723 (June 1963): 242.

[9] Richard Kendall, *Degas: Beyond Impressionism* (London: National Gallery Publications, 1996), 80.

[10] Paraphrased from a quote in Sara Lichtenstein, "Delacroix's Copies after Raphael—I," *The Burlington Magazine* 113, no. 822 (September 1971): 530.

[11] Reff has shown the critical importance to Degas of the art of Daumier, considered by many one of the greatest draftsmen of the nineteenth century. Degas eventually owned 750 lithographs by Daumier. See Theodore Reff, "Three Great Draftsmen: Ingres, Delacroix, and Daumier," in Ann Dumas et al., *The Private Collection of Edgar Degas* (New York: Metropolitan Museum of Art, 1997), 266–67.

[12] Theodore Reff, "The Technical Aspects of Degas's Art," *Metropolitan Museum Journal* 4 (1971): 141–66.

[13] Shelley Fletcher and Pia Desantis, "Degas: The Search for His Technique Continues," *The Burlington Magazine* 131, no. 1033 (April 1989): 256–65.

[14] See Shelley Sturman and Daphne Barbour's essay "Degas as Sculptor" in this catalogue on pages 75–88.

[15] Jill DeVonyar and Richard Kendall, *Degas and the Dance* (New York: Harry N. Abrams, 2002), 80–83.

[16] DeVonyar and Kendall, *Degas and the Dance,* 85.

[17] Edmond de Goncourt in his journal from 1874, in a translation into English derived from translations in both George T. M. Shackelford, *Degas: The Dancers* (Washington, DC: National Gallery of Art, 1984), 44, and Robert Gordon and Andrew Forge, *Degas* (New York: Harry N. Abrams, 1996), 64. This entry in de Goncourt's journal has been thought by many scholars, including Shackelford and Kendall, to refer to *The Rehearsal* (c. 1874) in the Burrell Collection (DeVonyar and Kendall, *Degas and the Dance,* 85). However, the x-radiograph of the painting in the Corcoran Gallery of Art provides convincing evidence that this painting is the one de Goncourt saw and described.

[18] Richard Kendall, *Degas Dancers* (New York: Universe, 1996), 83, 86.

[19] Ibid., 110–111.

[20] Shackelford, *Degas: The Dancers,* 86.

[21] Lemoisne, *Degas et son œuvre,* 1394–96.

[22] The two dancers featured in this drawing appear both in the National Gallery's Widener painting as well as in the Yale painting, while the pose of at least one or the other of them is altered in other closely-related works.

[23] Eugenia Parry Janis counts "eighty-one of the approximately 450 monotypes…served as the base for pastels." Eugenia Parry Janis, "The Role of the Monotype in the Working Method of Degas—I," *The Burlington Magazine* 109, no. 766 (January 1967): 20–27, 29.

[24] Fletcher and Desantis, "Degas: The Search for His Technique Continues," 265.

[25] See Reed and Shapiro, *Edgar Degas,* 220–58, for most complete and thorough description of this series of prints.

[26] Reff, "The Technical Aspects of Degas's Art," 149.

[27] Shackelford, *Degas: The Dancers,* 109, and Kendall, *Degas: Beyond Impressionism,* 77. Kendall writes, "*Two Dancers in Repose* and *Dancers in Repose* show the counterproof relationship to perfection," and, "By about 1890, his studio practice centered on the tracing of figures and designs, which allowed the motif to be synthesized, regrouped or reversed, and on counter-proofing (contre-épreuve) achieved by pressing an existing drawing onto a dampened sheet of paper to gain a reversed image."

[28] Reff, "The Technical Aspects of Degas's Art," 155.

[29] Anne I. Lockhart, "Three Monotypes by Edgar Degas," *Bulletin of the Cleveland Museum of Art* 64, no. 9 (November 1977): 305.

[30] Theodore Reff, *Degas: The Artist's Mind* (New York: Metropolitan Museum of Art, 1976): 270.

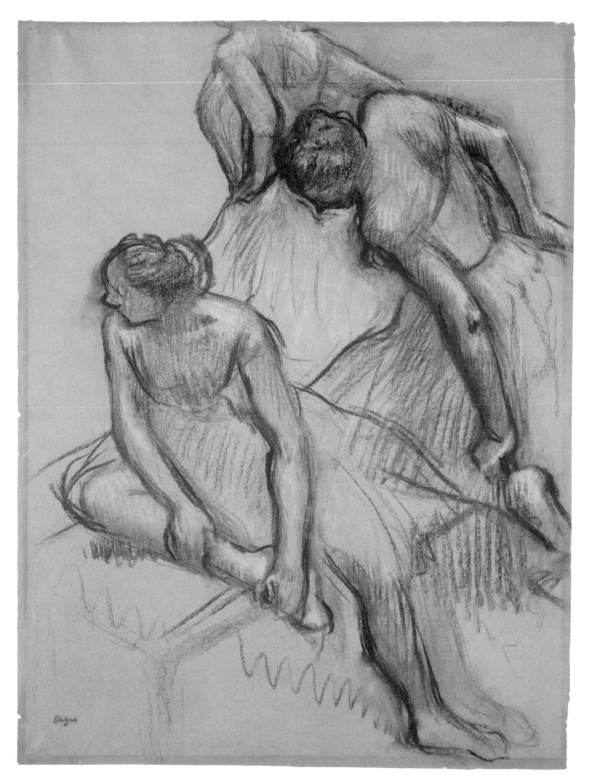

[CAT. 22]
Three Dancers
c. 1889
Charcoal and pastel
on blue-gray paper
23 1/4 x 17 11/16 in.

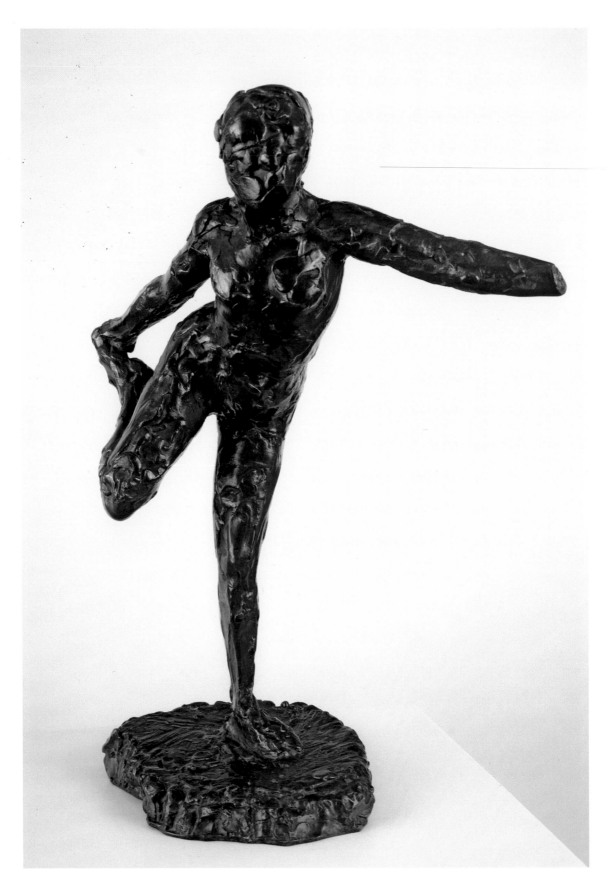

52

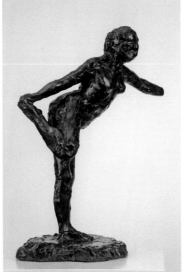
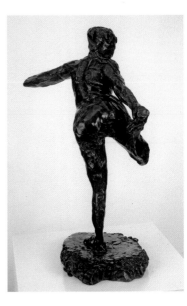
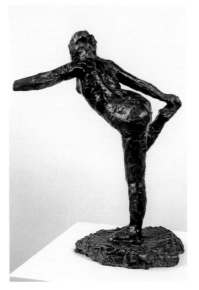
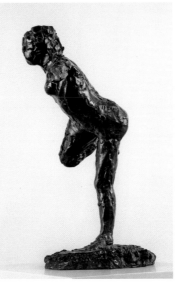
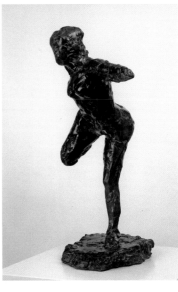

[CAT. 23]
*Dancer Holding
Her Right Foot in Her
Right Hand*
Original wax c. 1900–1911
Bronze
19 ¹³/₁₆ x 9 ¹/₂ x 14 ¹³/₁₆ in.

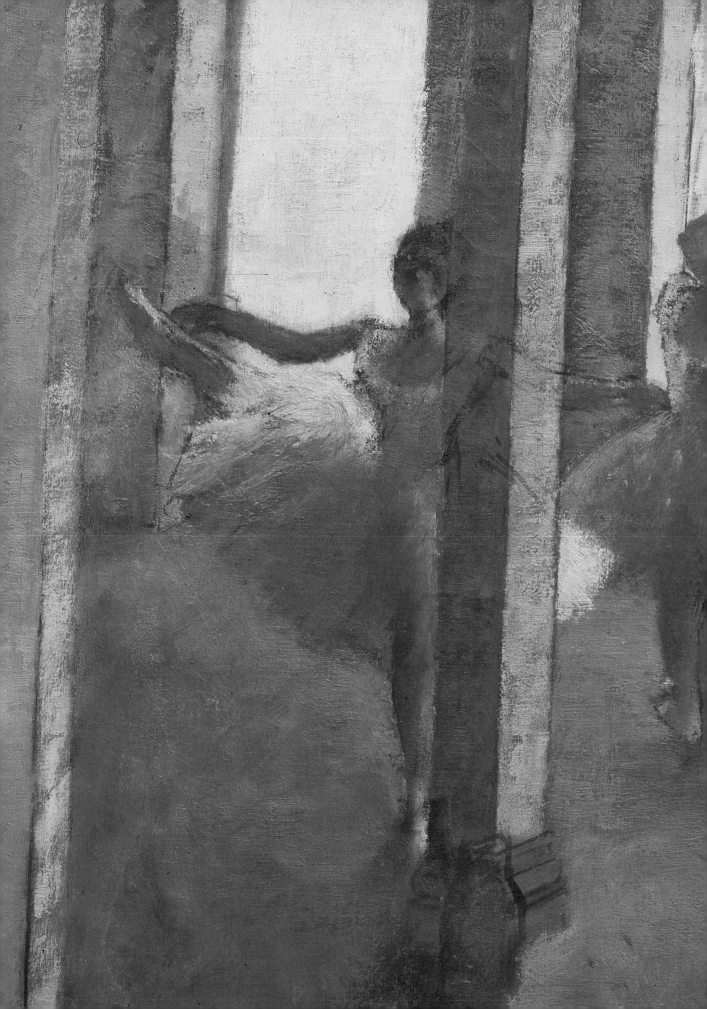

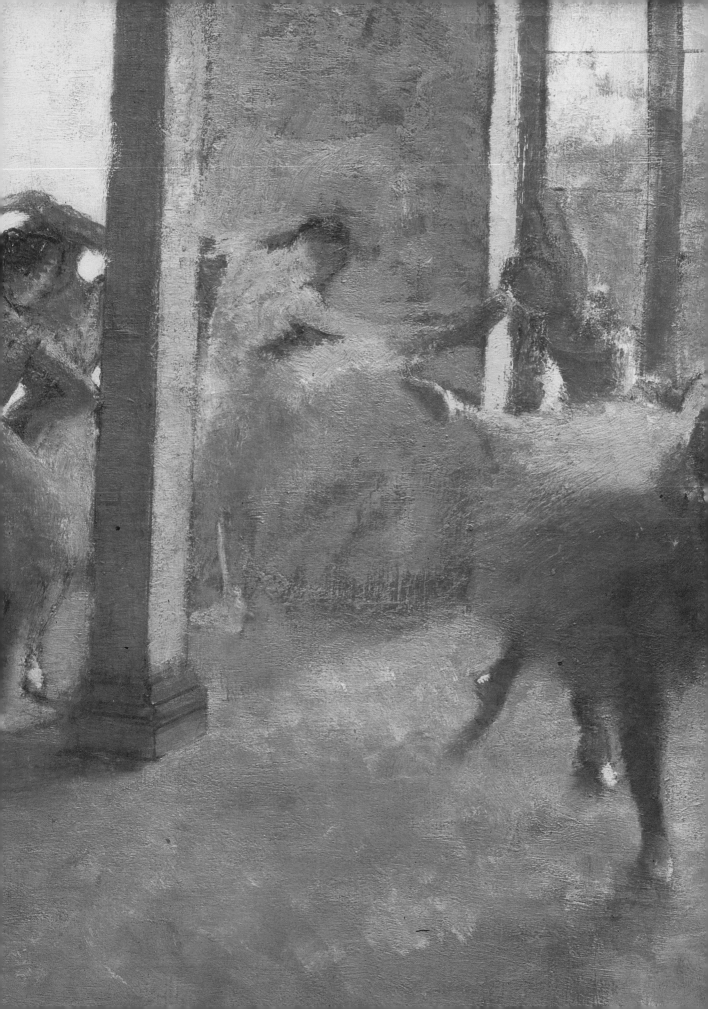

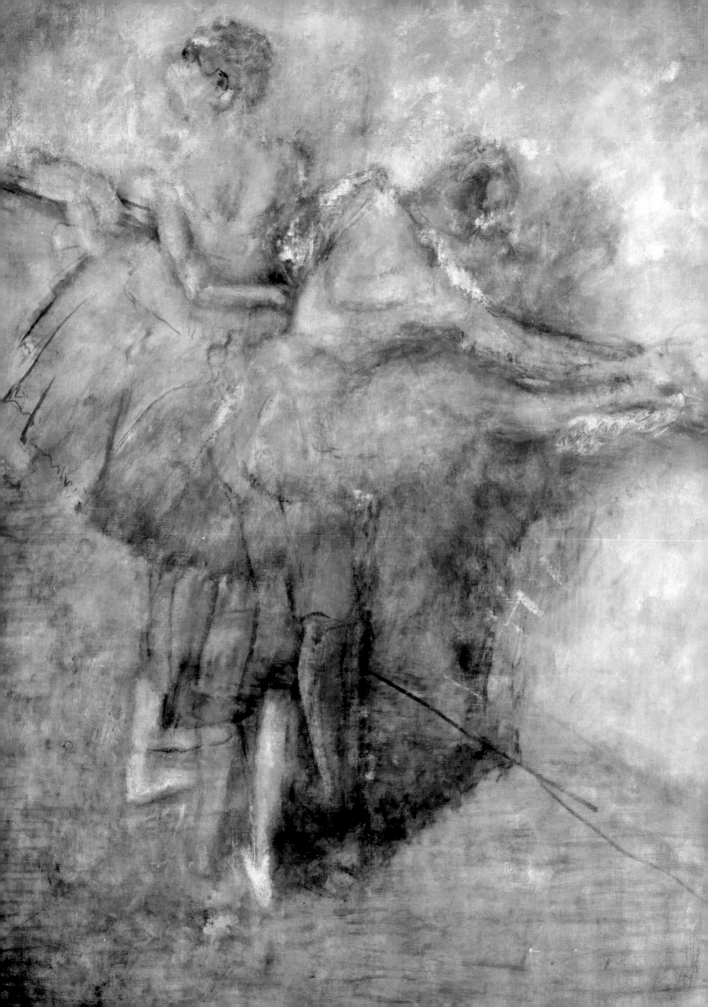

THE EVOLUTION OF *DANCERS AT THE BARRE*
A TECHNICAL STUDY

ELIZABETH STEELE

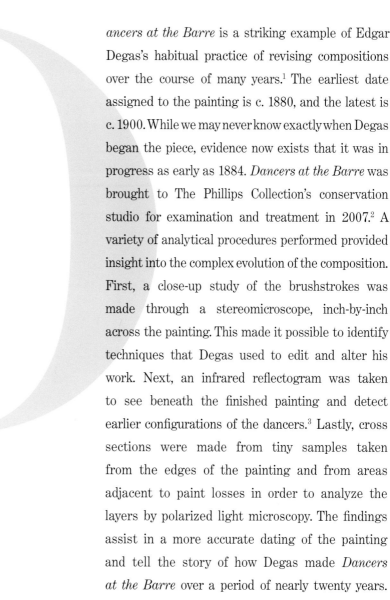

[FIG. 1]
Degas's numerous alterations to the composition are revealed in the infrared reflectogram of *Dancers at the Barre*.

ancers at the Barre is a striking example of Edgar Degas's habitual practice of revising compositions over the course of many years.[1] The earliest date assigned to the painting is c. 1880, and the latest is c. 1900. While we may never know exactly when Degas began the piece, evidence now exists that it was in progress as early as 1884. *Dancers at the Barre* was brought to The Phillips Collection's conservation studio for examination and treatment in 2007.[2] A variety of analytical procedures performed provided insight into the complex evolution of the composition. First, a close-up study of the brushstrokes was made through a stereomicroscope, inch-by-inch across the painting. This made it possible to identify techniques that Degas used to edit and alter his work. Next, an infrared reflectogram was taken to see beneath the finished painting and detect earlier configurations of the dancers.[3] Lastly, cross sections were made from tiny samples taken from the edges of the painting and from areas adjacent to paint losses in order to analyze the layers by polarized light microscopy. The findings assist in a more accurate dating of the painting and tell the story of how Degas made *Dancers at the Barre* over a period of nearly twenty years.

[FIG. 2]

[FIG. 3]

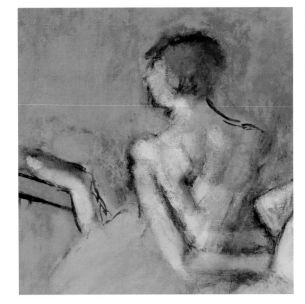

[FIG. 4]

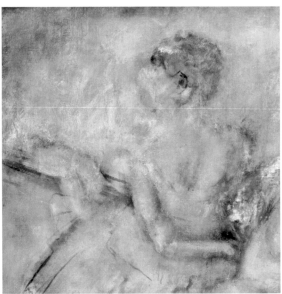

[FIG. 5]

[FIG. 2]

Degas's earlier location of
the outstretched arm
and leg shows through the
orange background above
their final position. The
flesh tone of the previous
leg is visible beneath her
forearm.

[FIG. 3]

The placement of the bar
and leg higher on the
canvas is apparent in the
infrared reflectogram.
Degas's multiple revisions
make her arm appear to
be in motion.

[FIG. 4]

Hints of flesh tone along
with a ghost image of
the initial leg placed higher
in the composition are
seen to the right and above
Degas's final version.

[FIG. 5]

Two positions of this leg,
one on top of the other,
are perceptible in the
infrared image. The higher
placement of the bar is
also apparent.

Emerging through lower layers of paint are ghost images of earlier heads and limbs of the dancers, showing that Degas initially placed the figures higher on the canvas. Infrared reflectography allowed us to see beneath the surface, yielding even more details. It is only when visual analysis and images of the underlayers of paint are combined, however, that the true magnitude of Degas's obsessive reworking becomes clear.

Close examination of the picture indicates that he moved the barre and both of the dancers' outstretched legs lower on the canvas (fig. 1). Flesh tones from an earlier placed leg lifted to the barre of the dancer on the right show through the surface below the final forearm (fig. 2). Two legs and multiple repositionings of her arm are visible in the infrared image of this passage (fig. 3). In the dancer on the left, an earlier rendition of her outstretched leg is seen in the thinly repainted passage above its current placement (fig. 4). Both versions of this leg are apparent in the underlayers of the paint (fig. 5). The most stunning revelation is the artist's multiple repositioning of the dancers' standing legs; signs of reworking exist all around the two standing legs on the surface of the painting (fig. 6), but it was not until the infrared image was made that the full extent of the revisions was known. Degas placed the leg of the left dancer in at least three different positions, and there are an astonishing five different poses for the standing leg of the figure on the right (fig. 7). Some of the legs that are visible in the infrared image look similar to drawings dating from the early 1880s made from a model: the calves are muscular and there is an indication of the back of the knee. Ultimately, the series of legs that Degas drew and later painted over shows a progression away from more realistic depictions to the final attenuated ones.

Further signs of the artist's revisions are evident in the dark "halos" above the dancers' heads. Degas applied thin layers of orange paint over earlier manifestations of the figures, barely concealing their brown hair after they were positioned lower and farther to the left on the canvas (fig. 8). He not only painted over some areas when revising the composition, but also scraped paint from the surface, sometimes down to the white preparation layer (fig. 9).[4] The head and shoulders of the figure on the right appear to have been reworked with rapidly applied brushstrokes. Additionally, he used his fingers to manipulate the paint while it was still wet. The artist's fingerprints are found throughout the picture when viewed under magnification, and the fingerprint found in white paint on the dancer's neck is so prominent as to be visible to the naked

eye (fig. 9). Degas often used his thumbs and fingers to edit his treatment of the paint, typically in a reductive fashion to push back a heavily applied brushstroke.

Additional proof that the dancers were originally higher on the canvas can be found in the position of their shoulders. Their previous placement is visible in the reworked paint above their torsos. In the same manner, Degas lowered their arms and the readily apparent ghost images from earlier states in underlayers are barely concealed. The awkwardly strained arm crossing the dancer's back was only minimally painted over after it was shifted down, and the former arm is still prominently visible. As such, this section is confusing because of the double arm imagery (fig. 8). He made so many attempts to reposition the outstretched arm of the figure on the right that, in the infrared image, it appears to be in motion (fig. 3). Degas makes little attempt to disguise his alterations. One might conclude that he was happy for his multiple retakes to be known by the viewer.

In each successive revision, as the figures descend lower on the canvas, they are increasingly unlike the observed model. *Dancer at the Barre* (1884–88) (fig. 12) is a drawing that appears to be made from the model and is presumably the one he used as the basis for the Phillips' painting. The figure leans forward with her leg and back parallel to the barre. However, by the time Degas completed the dancer in the Phillips painting, her torso is almost entirely turned outward, toward the viewer. Her spine and shoulders become nearly perpendicular to the barre instead of parallel to it. Her neck is no longer sunk back into her shoulder, and her head is raised. Degas obviously found the anatomy of the shoulder blades and spine of great interest and beauty. His artistic license is equally in evidence in the multiple revisions to the dancer on the left, whose contorted and strained posture becomes anatomically impossible. Degas's exaggeration of their poses could be explained as his wish to convey the visceral experience of stretching.

This exhibition brings together two works that are clearly the result of Degas's practice of reworking, revision, and tracing: the painting owned by The Phillips Collection and the pastel of the same title from the National Gallery of Canada (cat. 2, p. 18). Correspondence between the author and Anne Maheaux of the National Gallery led to the exchange of tracings of the two compositions on transparent Mylar.[5] When the tracing of the pastel was laid on top of the painting, it validated suspicions that the two works are related. While the dancers

[FIG. 6]
Indications of reworking the paint are discernable to the left and right of these two legs.

[FIG. 7]
Degas's obsessive reworking of the composition manifests itself in the large number of attempts made to establish the dancers' standing legs. He placed the leg on the left in three different places and tried the one on the right in five stances.

[FIG. 8]
The dark halos above the dancers' heads signal that they were initially painted higher and to the right on the canvas. This same shift is visible in the strained arm that crosses the dancer's back, the earlier version only minimally painted over.

[FIG. 9]
A close-up of the neck and chin of the dancer on the right reveals that Degas removed paint to make alterations, evidenced by the scrape marks that extend through to the white preparation layer. He used his fingers to edit the paint in her neck—his fingerprints are visible left of center in this image.

[FIG. 6]

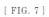

[FIG. 7]

[FIG. 8]

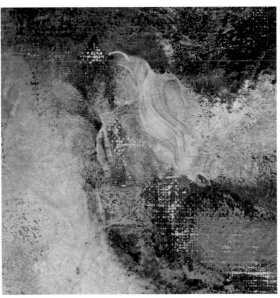

[FIG. 9]

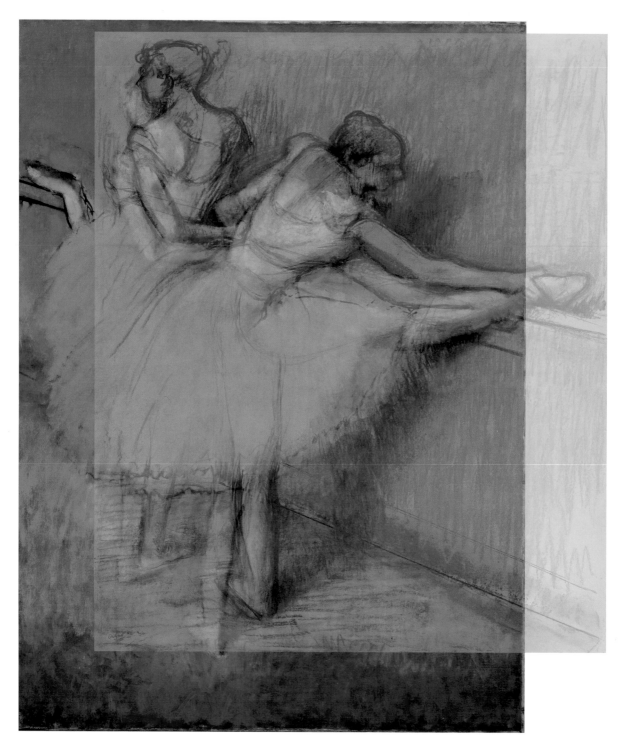

[FIG. 10]
Overlay of the National
Gallery of Canada's
pastel on The Phillips
Collection's painting

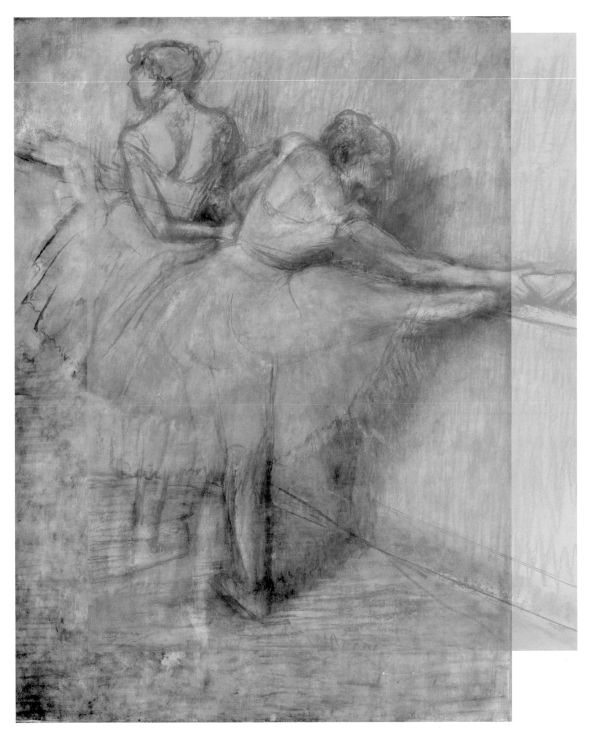

[FIG. 11]
Overlay of the National
Gallery of Canada's
pastel on the infrared
reflectogram of The Phillips
Collection's painting

have similar dimensions and overall proportion, the alignment of arms, legs, and heads does not correspond perfectly (fig. 10). However, the pastel lines up closely with the ghost images found in the reworked passages and the revisions found in the infrared image (fig. 11). The placement of the heads in the pastel aligns with the "dark halos" above the dancers' heads in the painting. Likewise, the shoulders in the pastel can be matched up with the brushstrokes emerging through the upper layers of the shoulders when the figures were placed higher on the canvas. The standing leg of the figure on the right, with a heavier calf and more fully grounded foot in the pastel, is detectable in the infrared image of the painting (fig. 7). These findings confirm that the configuration of the dancers in the National Gallery's pastel existed as an earlier state in the Phillips' painted composition.

Given Degas's predilection to make multiple versions of a subject, it is probable that both the Canadian pastel and the Phillips painting were traced from a drawing that has since been lost. (Two other drawings with the same composition as *Dancers at the Barre* were published in the 1946 catalogue raisonné, but their current location is unknown.) It is likely that each dancer was conceived from an individually posed nude model (fig. 3, p. 20, and fig. 12). Subsequently, Degas combined the drawings to arrive at the composition of *Dancers at the Barre.* The sequence of which came first, pastel or painting, will remain a mystery since Degas's reuse of the same drawings over and over again is renowned. Visitors to Degas's studio reported seeing large numbers of drawings and tracings of figures pinned to walls and other surfaces.[6] It is also possible that at an early stage Degas may have gone back and forth between the works.

Despite his experimentation, Degas still began his compositions in an academic fashion.[7] This can be seen in the contour lines of the body of the dancer on the right, made visible in the infrared reflectogram. He first placed the nude on the canvas, then added her costume and developed the background. Horizontal lines depicting the studio floor are also found in the infrared image, similar to the foreground of the Canadian pastel. These lines slowly disappear in the painting and evolve into a dense mass of vertical brushstrokes, probably in response to the numerous alterations made to the legs. The shadow cast on the wall by the dancer on the right is apparent in the infrared image; this detail features prominently in the pastel, but in the painting it is absorbed into the orange background and virtually disappears. Finally, the dancers' skirts appear to have been shorter in an earlier stage of the painting, falling

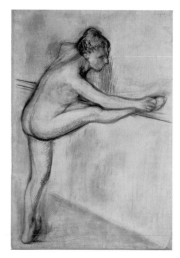

[FIG. 12]
Dancer at the Barre
1884–88
Charcoal heightened with
pastel on paper
41 x 29 ½ in.

[FIG. 13]

[FIG. 14]

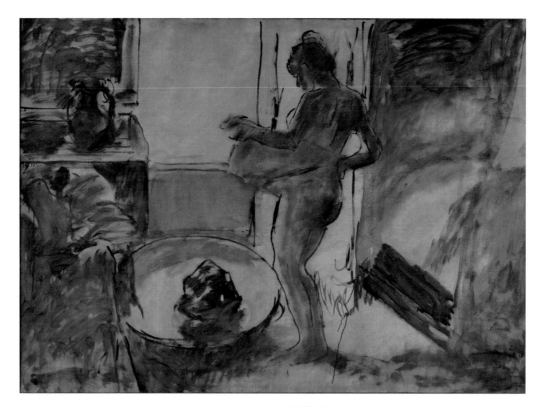

[FIG. 15]
Nude Woman
Drying Herself
c. 1884–86
Oil on canvas
59 3/$_8$ x 84 1/$_8$ in.

[FIG. 13]
The straight edge of
the paper tape is faintly
detectible in this close-up
of the upper right side
of the canvas.

[FIG. 14]
Purple paint used by Degas
for the monochromatic
sketch that lies beneath
Dancers at the Barre is
found along all four edges.

above the knee. Contour lines of shorter tutus are visible in the infrared and also show through the light blue paint upon close inspection of the paint film. A further indication that the skirts were made longer is apparent in the orange and brown colors of the wall that are evident beneath the thinly painted blue additions.

An investigation of the edges of *Dancers at the Barre* suggests that Degas cut this composition down from a larger canvas. The picture is lined onto a secondary canvas and brown paper tape is wrapped around the stretcher onto the front of the picture. This type of finish to the sides is typically employed by restorers to cover the cut edges of the canvas where the tacking margins are removed.[8] No information exists in the Phillips's archives to indicate when the lining may have taken place. Close inspection reveals that Degas's paint is found on the brown paper on all four sides (fig. 13). It can therefore be deduced that the artist ordered the canvas reduced in size from a larger format because he

continued painting the work after it was affixed to the lining. Degas was very familiar with the restoration process and employed liners in an unorthodox way to piece together his pastels, which were frequently composed of several sheets of paper.[9] In Ambroise Vollard's biography of the artist, he recounts Degas's relationship with restorer Charles Chapuis.[10] While the reported discussion between Degas and Chapuis concerned lining works by other painters that the artist owned, it is conceivable that Degas could have had one of his own pictures lined as well.

A layer of purple paint that exists on all four sides beneath the brown paper tape (fig. 14) supports the theory that the canvas was cut down. Its presence universally around the perimeter suggests that a larger composition was cropped by the artist when it was an unfinished painted sketch. Degas generally began with a rough charcoal or graphite pencil drawing on the canvas, on top of which he painted a monochromatic sketch. The Brooklyn Museum's unfinished *Nude Woman Drying Herself* (c. 1884–92) (fig. 15) provides an example of the state that *Dancers at the Barre* may have been in when Degas had it cut down and lined onto a secondary canvas. As a preliminary painted sketch, the paint thickness would vary from one passage to the next. Cross sections taken throughout the composition (figs. 16a–c) show the purple paint to be applied as a thin wash in some places but more full-bodied in others. It is visible in a relatively thick and uniform application above the white ground layer in cross section A. In cross section B, it is present on the left and right sides of the paint sample, but absent in the middle, which is consistent with a painted sketch in which not all of the white preparation layer would be covered. Cross section C shows the purple layer throughout the sample but very thin in the middle, indicative of a wash application of paint. A thin layer of a black drawing material can also be seen between the white ground and the purple paint, suggesting that the first marks on the canvas were made with either charcoal or graphite pencil, consistent with the artist's traditional technique.[11]

Finally, when the Phillips conservators took the painting off its stretcher, they discovered something unexpected. Two graphite pencil inscriptions were found on the side of the stretcher facing the back of the canvas, hidden from view and completely unknown. Each inscription is in a different hand, signed and dated with a Paris street address. Unfortunately, the identity of the person who signed his or her name in very large cursive is not decipherable, but the address "rue de la Sablière

[FIG. 16A]
A full bodied application
of purple paint belonging
to the monochromatic
sketch lies above the white
preparation layer.

[FIG. 16A]

[FIG. 16B]
Purple paint is present on
the right and left of the
cross-section but is absent
in the middle.

[FIG. 16B]

[FIG. 16C]
Dark drawing material
(charcoal or graphite pencil)
is faintly visible between
the white ground and a
wash application of the
purple paint. Six to eight
layers of paint are found
in this sample taken from
the background and attests
to the numerous occasions
that Degas reworked
the picture.

[FIG. 16C]

no. 22, 20 Decembre 1884" is very clear (fig. 17). Only a few people besides Degas would have had access to the interior of the stretcher: the stretcher-maker, an artists' colorman,[12] or a restorer. The address does not correspond to any known merchant in Paris at the time, nor is it any address ever associated with Degas. In the early 1880s, Degas would have been in the initial stages of working on *Dancers at the Barre*. It is probable that this inscription and address could be that of the restorer who cut down and lined the canvas at the artist's request.

The second inscription is much more legible and reads "Ch. Chapuis, Rentoiler à tableaux, 11 rue Cretet, Paris, Juin, 1919 (fig. 18)."[13] At this date, *Dancers at the Barre* was in the hands of Ambroise Vollard, who bought the work from the first Degas estate sale in 1918. It is not known what Chapuis may have done to the painting, since it does not appear to have been lined a second time. However, a torn and rust-stained set of tack holes exists alongside the current tacks on the lining fabric. The tacking margin had clearly become worn around the first set of tacks, and was perhaps causing the painting to disengage from its stretcher. It is possible that Vollard hired Chapuis to restretch the canvas or perform some other treatment to the work prior to selling it. Any work he did on the painting is not known (as it has suffered almost no damage and has only been minimally restored in its history), but Chapuis did follow suit from his predecessor on the rue Sablière, signing the inside of the stretcher bar before placing the canvas back on its auxiliary support. Like a message in a bottle, the two restorers left evidence of having worked on the painting.

The present study of *Dancers at the Barre* provides a glimpse into Degas's complex process and approach, and reveals the evolution of the composition over two decades. While the 1884 inscription found on its stretcher verifies that the painting's inception dates to the early 1880s, its finished state is stylistically closer to 1900. Despite Degas's multiple revisions of the composition, a sense of freshness continues to imbue the painting. The brushwork has the feel of a quick but assured hand. The palette is electric, reminiscent of his later pastels. The dark contour lines used to characterize the dancers' bodies and costumes are applied with a direct facility that only a master could summon. In the artist's revision of *Dancers at the Barre,* he moved from the observed image through a series of transformations to a final state that reflects the bold certainty of his mature work.

[FIG. 17]
Inscription dated 1884
found on the interior of
the stretcher

[FIG. 18]
Inscription dated 1919
found on the interior of
the stretcher

[1] This topic had been treated in depth by many scholars. This essay was particularly informed by discussions in David Bomford, Sarah Herring, Jo Kirby, Christopher Riopelle, and Ashok Roy, *Art in the Making: Degas* (London: National Gallery Publications, 2004); Richard Kendall, *Degas: Beyond Impressionism* (London: National Gallery Publications, 1996); and Anne F. Maheux, *Degas Pastels* (Ottawa: National Gallery of Canada, 1988).

[2] Although its state of preservation was relatively good, the paint film had developed some fragile areas and the surface coating had discolored yellow. A review of its history indicates that the picture had remained relatively untouched since it entered the collection in 1944. There is no record in the museum's files that any major restoration has taken place on this picture since its acquisition by The Phillips Collection. Layers of grime and discolored varnish were removed from the surface. Passages of lifting paint were re-adhered to the canvas. Minor losses were filled and retouched. A thin application of varnish was applied to the surface.

[3] An infrared reflectogram is an image taken with a camera that is sensitive to light in the infrared range. Many pigments are transparent or semitransparent in infrared, making it possible to see through certain paint layers. Other pigments absorb light in this part of the spectrum and will appear dark in an infrared reflectogram. This technique is useful to detect underdrawings or changes made to the composition.

[4] These passages appear bright white with jagged edges in the infrared reflectogram.

[5] Maheux, *Degas Pastels,* 56–61. The close relationship between the painting owned by the Phillips and the pastel owned by the National Gallery of Canada has been previously noted by Jean Sutherland Boggs and Anne Maheux. I am grateful to Maheux for her collaboration with the Phillips in the exchange of tracings of the respective works on Mylar.

[6] Kendall, *Degas: Beyond Impressionism,* 80–82; Bomford et al., *Art in the Making: Degas,* 30–31; Maheux, *Degas Pastels,* 45.

[7] Kendall, *Degas: Beyond Impressionism,* 81, 106–115; Bomford et al., *Art in the Making: Degas,* 22.

[8] Lining a painting involves attaching a secondary support, typically another linen canvas, to the reverse of the original canvas using an adhesive such as glue, wax, or more recently, synthetic resin adhesives.

[9] Bomford et al., *Art in the Making: Degas,* 30–31; Kendall, *Degas: Beyond Impressionism,* 86; Maheux, *Degas Pastels,* 45–50.

[10] Ambroise Vollard, *Degas: An Intimate Portrait* (New York: Crown Publishers, 1937), 70–71. Another instance of the artist having cropped and lined one of his own canvases has been documented in the National Gallery of London's *Miss La La at the Cirque Fernando* (1879) in Bomford et al., *Art in the Making: Degas,* 82.

[11] I am grateful to Barbara Berrie, conservation scientist at the National Gallery of Art, who generously provided her expertise to interpret the cross sections.

[12] An artist's colorman is a nineteenth-century term for a merchant who supplied artists with their materials.

[13] Chapuis was a restorer used by both Vollard and Degas. Ambroise Vollard, *Recollections of a Picture Dealer* (Boston: Little, Brown and Company, 1936). *Rentoiler* translated from French means reliner and can also be interpreted as restorer.

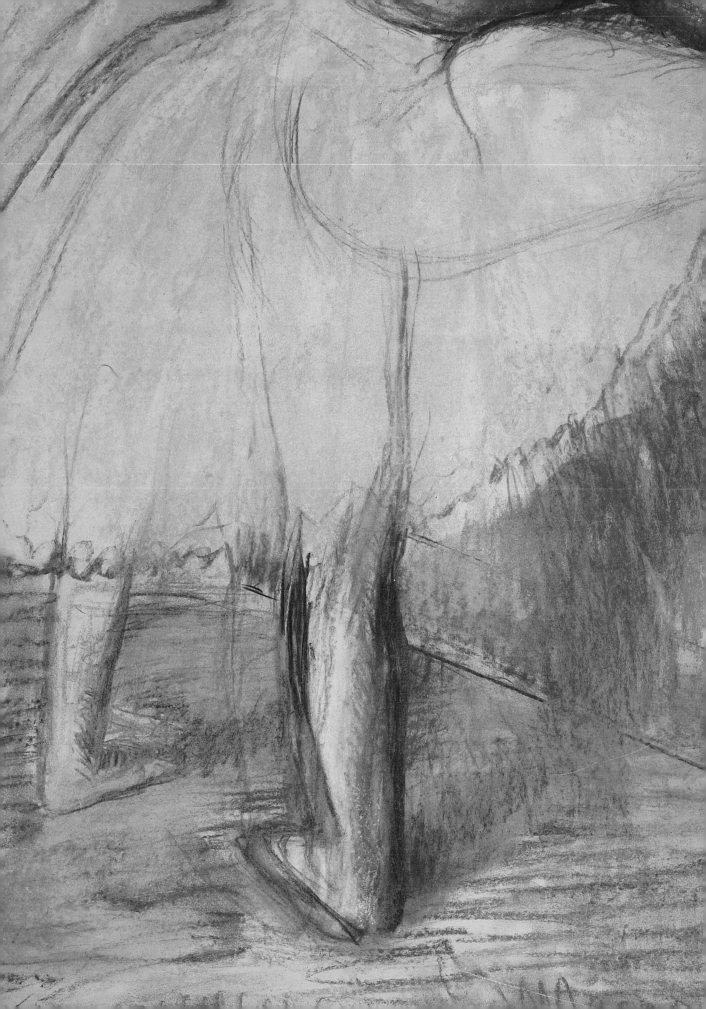

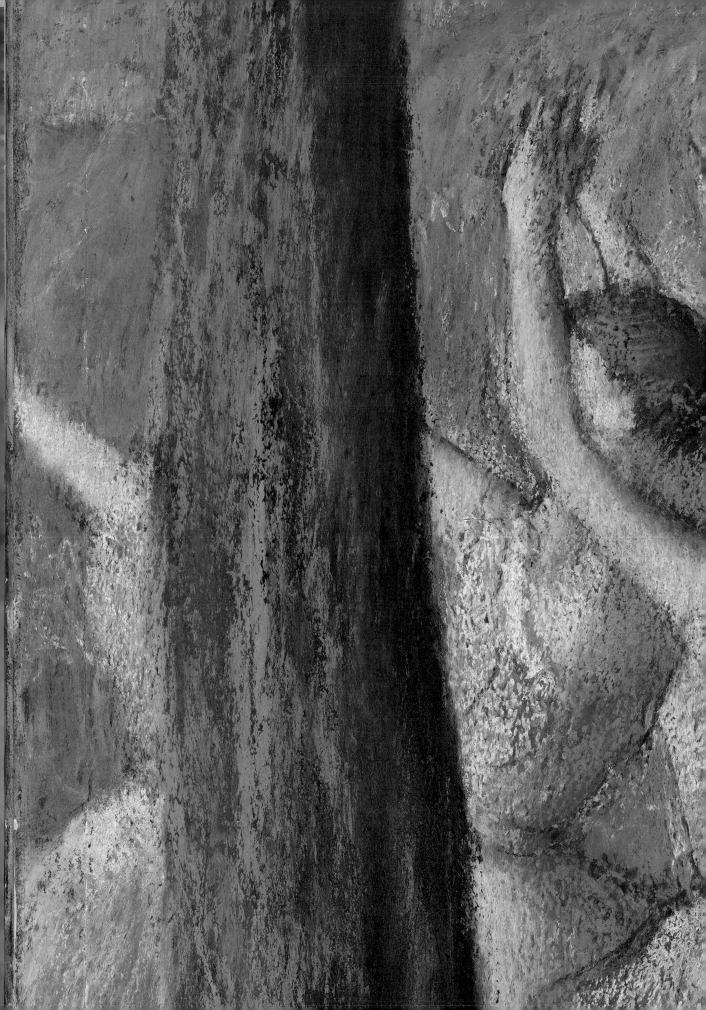

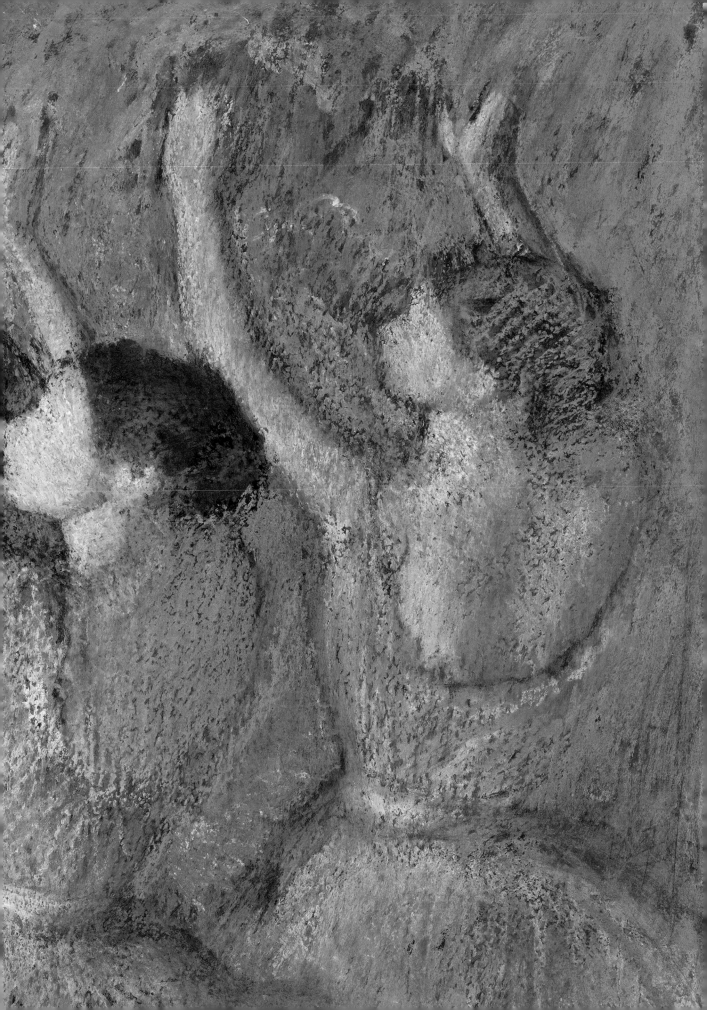

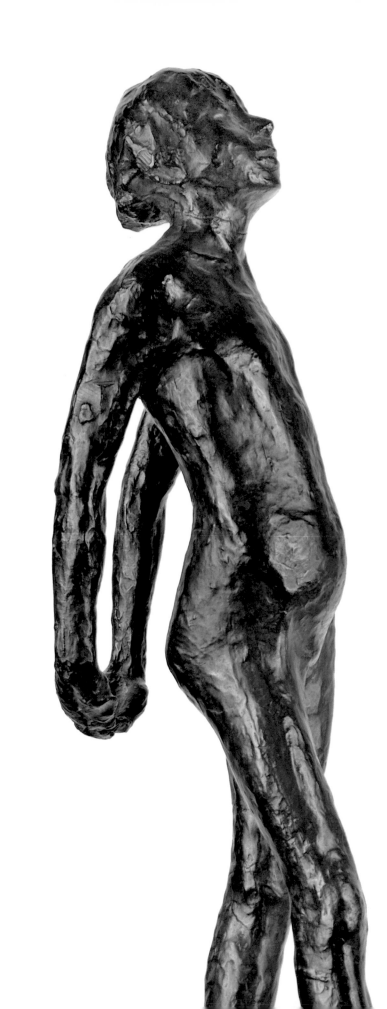

DEGAS AS SCULPTOR

Shelley Sturman and Daphne Barbour

Legend has it that Edgar Degas only began to sculpt as his eyesight failed and prevented him from painting. Yet throughout his career, contemporaries record that when they visited his studio they were just as likely to find him modeling in wax and clay as they were to find him at the easel.[1] Notorious for modifying and even destroying his own creations, Degas employed the same pattern of working and reworking in his sculpture that he did in his paintings, prints, and drawings. Ambroise Vollard, Degas's biographer and dealer, described a visit to Degas's studio in which he found the artist modeling a dancer in wax that he claimed was almost complete and ready for Hébrard (the foundry that cast his sculpture into bronze after his death). But upon his return the following day, Vollard was astonished to find that the sculpture had been reduced to a ball of wax. "All that you think about, Vollard," Degas is purported to have said, "is what it was worth. But had you given me a hat full of diamonds, I would not have enjoyed as much pleasure as I did in demolishing it only to begin again."[2] Degas's sculptures, generally single figures without context, must be evaluated differently from his works in other media.

Through sculpture, Degas could focus on a particular pose, as well as the states of gravity or weightlessness, often using the female nude as the subject and the dance as his means for exploring movement. Three sculptures of nude dancers are included in *Dancers at the Barre: Point and Counterpoint*—each one provides a unique perspective from which to understand the artist in three dimensions. The first, *Nude Study for Little Dancer Aged Fourteen* (original wax c. 1878–81) (cat. 24), represents a subject that Degas studied in various media from numerous perspectives over many years. *Dancer Moving Forward, Arms Raised* (original wax c. 1882–98) (cat. 25) exemplifies Degas's explorations of gravity and lightness, and *Dancer Holding Her Right Foot in Her Right Hand* (original wax c. 1900–1911) (cat. 23) introduces a posture that recurs repeatedly and in many variations within his sculptural oeuvre.

HISTORY OF THE SCULPTURE

During his lifetime, Edgar Degas exhibited only one sculpture publicly, *Little Dancer Aged Fourteen* (1878–81) (fig. 1), in one exhibition, the sixth impressionist exhibition of 1881. Yet *Little Dancer Aged Fourteen* transcended the boundaries of late nineteenth-century French sculpture, causing a strong reaction from Parisian critics. "M. Degas has overthrown the traditions of sculpture just as he long since shook the conventions of paintings," wrote one critic.[3] The rest of his sculpture was private, seen only by the privileged who visited his studio, and the extent of his productivity was not known until after his death.

It is unclear when Degas began to make sculpture, although his earliest extant works date from 1859 to 1860. Technical studies reveal that most of his surviving sculptures were modeled in malleable materials such as wax, clay, or plastiline (nondrying modeling clay).[4] Many of his works crumbled during his own lifetime.[5] Five years before he died in 1917, Degas was forced to move from his home on the rue Victor Massé to the boulevard de Clichy. The number of works lost in that process is unknown, but the damage to his spirit is sadly quantifiable as he never worked in any medium again.

RIGHT:
[CAT. 25]
Dancer Moving Forward, Arms Raised
Original wax c. 1882–98
Bronze
13³/₄ x 6⁷/₈ x 6 in.

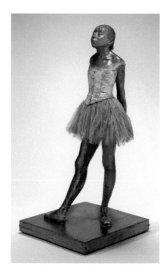

[FIG. 1]
Little Dancer Aged Fourteen
1878–81
Pigmented beeswax, clay, metal armature, human hair, silk and linen ribbon, cotton and silk tutu, cotton bodice, linen slippers, on wooden base
Overall without base
38¹⁵/₁₆ x 13¹¹/₁₆ x 13⁷/₈ in.

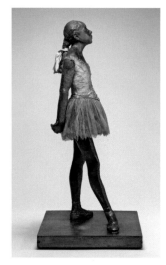

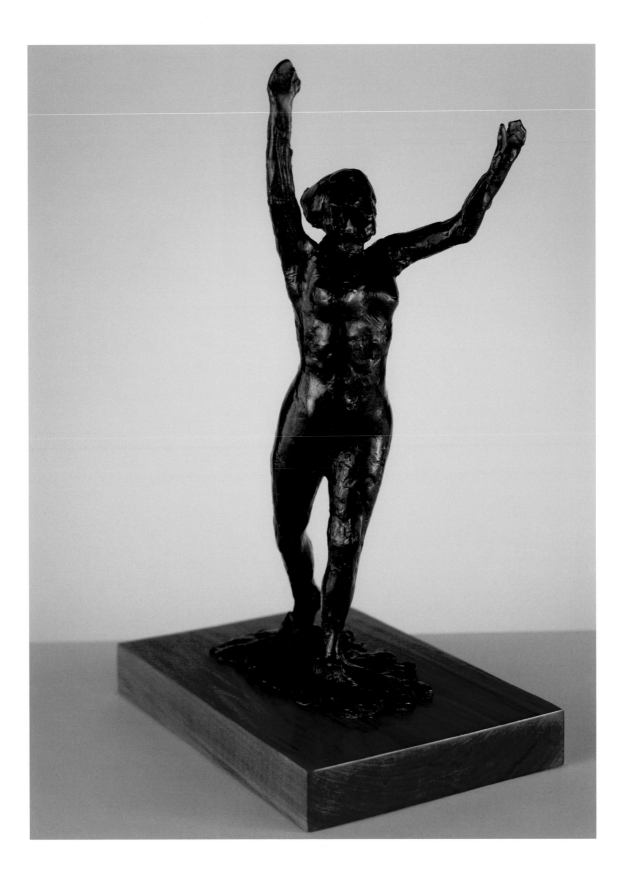

THE BRONZES

After Degas died, Paul Durand-Ruel and Ambrose Vollard compiled an
inventory of the contents of his studio in December 1917 and January
1918. The inventory lists eighty statuettes by Degas.[6] Joseph Durand-
Ruel, Degas's dealer, accompanied his father, Paul, to the studio, and
in 1919 his letters to the art critic Royal Cortissoz were published in
the *New York Herald Tribune*. It is Joseph's comments regarding the
remnant sculptures and fragments of sculptures found in Degas's studio
that are most often quoted. His numbers are generalizations, and one
assumes that only the salvageable pieces were saved and inventoried.[7]

*"When I made the inventory of Degas's possessions, I found about 150
pieces scattered over his three floors in every possible place. Most of them
were in pieces, some almost reduced to dust. We put apart all those that
we thought might be seen, which was about one hundred, and we made
an inventory of them. Out of these thirty are about valueless; thirty badly
broken up and very sketchy; the remaining thirty are quite fine."*[8]

Ultimately, seventy-four sculptures were cast into bronze[9] after a con-
tract was signed between the heirs and the Parisian foundry Adrien-
Aurélien Hébrard in May 1918.[10] Four of the waxes did not survive the
molding and casting, and therefore only seventy original sculptures exist
today.[11] The contract stipulated that each sculpture would be reproduced

in bronze twenty-two times: twenty sculptures individually lettered "A" through "T" which would be sold, one marked "HER.D" reserved for the heirs ("héritiers Degas"), and one marked "HER" allocated to the found-ry.[12] Each bronze received Degas's signature stamp (estate cachet), the mark of the founder, and the individual bronze number and letter of the series (fig. 2). However, recent scholarship indicates that the contract was not followed as closely as had been believed; the full complement of twenty-two casts of each sculpture was not completed, extra casts were made of some objects, and some marks differ from the contract stipulations.[13] But the posthumous casting into bronze of the viable works brought public attention to Degas as a sculptor.

For years, scholars believed that Degas's original sculptures were de-stroyed in the process of casting the posthumous bronzes. However, in the early 1950s, the surviving seventy originals surfaced after decades of being hidden in Paris.[14] The entire corpus was purchased by Mr. and Mrs. Paul Mellon in 1956 and the majority of the works were given to the National Gallery of Art.[15]

SCULPTURES IN THE EXHIBITION

*Just as dance was the most frequent subject
of Degas's paintings, the same is true for his sculpture
of which more than half depict dancers.*

Nude Study for Little Dancer Aged Fourteen

Nude Study for Little Dancer Aged Fourteen (cat. 24), is cast from an original wax housed today in the collection of the National Gallery of Art, Washington.[16] Scholars assume that this sculpture served as a three-dimensional model for the larger, dressed *Little Dancer Aged Fourteen* (fig. 1). Clearly, both works represent the same young girl, identified as Marie van Goethem.[17] Born of Belgian working-class parents, Marie van Goethem embodied the persona of a late nineteenth-century Parisian ballerina. At the time, dancers were presumed to be of dubious moral-ity.[18] Here Degas captured a young dancer still innocent in her youth, but poised at a critical crossroad. At fourteen, she would have been competing

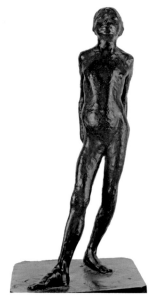

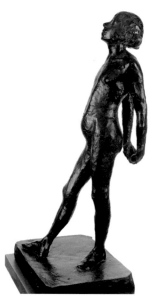

[CAT. 26]
Study of a Nude Dancer
c. 1878–79 or later
Black chalk and charcoal on
mauve-pink laid paper
18 5/8 x 12 1/4 in.

[CAT. 24]
Nude Study for Little
Dancer Aged Fourteen
(multiple views)

RIGHT:
[FIG. 3]
Detail of cat. 24, *Nude*
Study for Little Dancer
Aged Fourteen, shows top
of the base and change in
placement of right foot

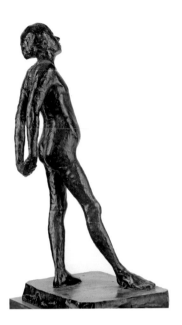

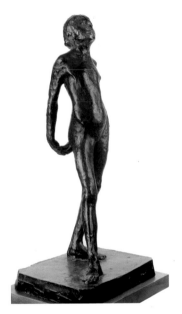

for, or indeed already entered, the second quadrille, the first level of a ballerina's professional career.[19]

Many drawings of both dressed and nude studies of Marie van Goethem have further linked the two sculptures. Although there is neither a definitive chronology of the drawings nor a precise understanding of their role in the fabrication of the sculptures, there is no doubt that Degas made them as a means to understand form in the round. Richard Kendall counts no fewer than seventeen vantage points among the drawings, reflecting Degas's view as he circled the stationary model.[20] One charcoal drawing in particular depicts the subject in the nude from three points of view and is especially relevant to the fabrication of the sculpture.[21] Degas not only envisioned this work in the round as he sketched, but he also formulated the process of creating the sculpture. In the upper-right corner of the drawing is a doodle of the lead pipe armature that exists inside *Little Dancer Aged Fourteen* and was discovered through a technical study of the piece.[22] Of greater relevance to the sculpture is the central figure in the same drawing. The hint of a line at an angle to the feet suggests the figure is on a base. The original wax sculpture of *Nude Study* is the only example in Degas's sculptural repertoire to include a cast plaster base. The black chalk drawing from Oslo, *Study of a Nude Dancer* (cat. 26), introduces yet another view of the young dancer seen slightly from above. It is tempting to read the line in front of her left foot as a cursory indication of a base, drawing further parallels to the sculpture.

In order to understand how Degas made the sculpture, scholars have studied the original wax *Nude Study*. Its fabrication, identified through a recent technical study, reveals that the original sculpture was cast wax over a plaster core. The arms, however, were modeled separately and attached at the shoulders, possibly allowing Degas, the consummate perfectionist, to manipulate the pose of the arms, even in a cast wax.[23] A change to the position of the right foot seen in the plaster base is also recorded in its bronze (fig. 3). The impression left in plaster from the foot before it was moved shows that at one time the right foot was turned out to a greater degree.

The chemical patination of the bronze *Nude Study for Little Dancer Aged Fourteen* provides an example of a toned surface intended to loosely simulate the color of the original wax. Not only is the deep red emulated, but some areas of darkened discoloration present on the upward facing surfaces of the original (such as on the face and on the chest)

are also recorded in the bronze. Albino Palazzolo, the bronze founder employed by Hébrard, intentionally emulated the discolored and dirty surfaces of the original wax on some of the bronzes.[24]

Dancer Moving Forward, Arms Raised

Dancer Moving Forward, Arms Raised (cat. 25) belongs to a series of dancers in this particular position, with raised limbs that allude to classical prototypes.[25] Cast from an original wax in the collection of the National Gallery of Art, the work has been likened by Charles Millard to the celebrated sculpture from antiquity *Dancing Faun* (first-century Roman copy of a Hellenistic original), located in Naples. Millard considers Degas's sculpture to be nearly a copy.[26] Although his observation may be overstated, his point that *Dancer Moving Forward* is inspired by a classical antecedent is justified. Degas was granted permission to copy antiquities at the Louvre, and he had firsthand knowledge of these works from his trips to Italy.[27] According to the writer Henry Hertz, Degas believed his dancers "followed the Greek tradition purely and simply, almost all antique statues representing the movement and balance of rhythmic dance."[28] Here, the dancer is shown on demi-pointe, her voluptuous physique challenging the delicate balance required of this position.[29] *Dancers in Rose* (cat. 27) depicts dancers drawn in a similar posture, in pastel; yet the combination of muted forms intrinsic to the medium with the repetition of the pose of three dancers creates a less earthbound, and more rhythmic, almost ethereal quality.

Degas experimented with the notion of weightlessness in another larger sculpture that shares the same title (fig. 4). The original of this particular work was lost in the casting process and is known today only through its bronze counterpart. The external iron armature that sustains the piece is a replacement.[30] Yet vestiges of an original external support evident in the bronze suggest that the dancer could have been positioned to stand on the ball of her left foot or even be lifted off the ground entirely.[31] If this assumption is correct, the larger *Dancer Moving Forward* is unique in that Degas intended the sculpture to appear weightless. This simple adaptation enabled him to transform the earthbound *Dancer Moving Forward* included in the exhibition into the larger *Dancer Moving Forward*, which challenges the confines of gravity.

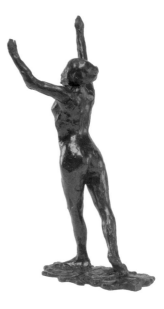

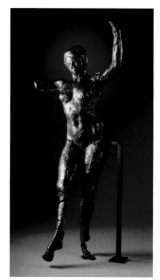

TOP:
[CAT. 25]
Dancer Moving Forward,
Arms Raised
(alternate view)

ABOVE:
[FIG. 4]
Dancer Moving Forward, Arms
Raised, Right Leg Forward
Original wax c. 1882–98
Bronze
26 x 12 1/2 x 9 1/16 in.

RIGHT:
[CAT. 27]
Dancers in Rose
c. 1900
Pastel on paper
33 1/8 x 22 7/8 in.

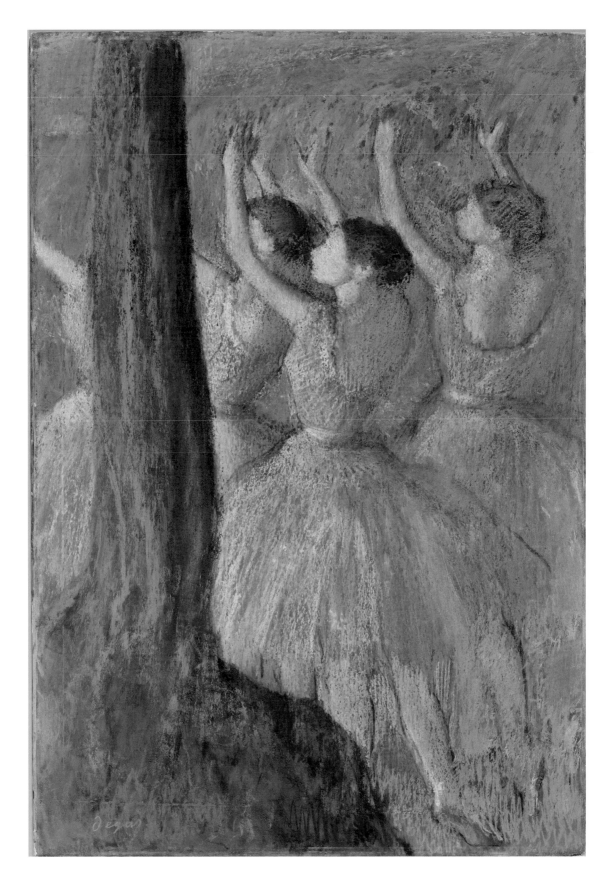

Dancer Holding Her Right Foot in Her Right Hand

Dancer Holding Her Right Foot in Her Right Hand (cat. 23),[32] is one of two sculptures with the same title that depicts a figure balanced on the left leg, right leg bent behind, and left arm extended in front. Both original wax sculptures are in the collection of the National Gallery of Art. Comparison of the two versions prompts some notable observations regarding posture and condition. The sculpture included in the exhibition is much bigger than its counterpart, and the figure leans forward with a distinct bend at the waist. It is possible that the pose depicted in the exhibition sculpture would have been the first one Degas modeled in wax. Technical examination combined with material analysis and radiography of the original wax reveals that the figure probably broke into several pieces, likely owing to its size and lack of sufficient support for the cantilevered pose.[33] From the visible joins in the wax, all discernible in the present bronze, it may be speculated that the sculpture was

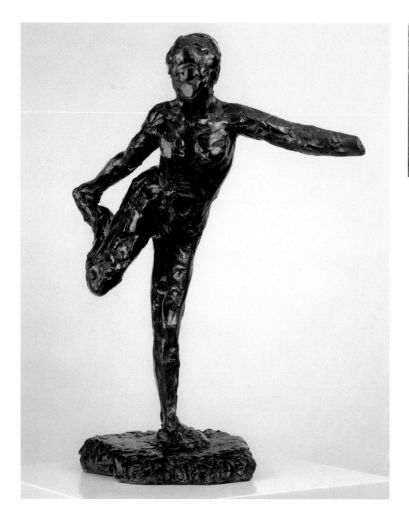

[FIG. 5]
Detail of cat. 23, *Dancer Holding Her Right Foot in Her Right Hand,* shows tool marks (cast into bronze from original wax) seen on top of the base.

[CAT. 23]
Dancer Holding Her Right Foot in Her Right Hand

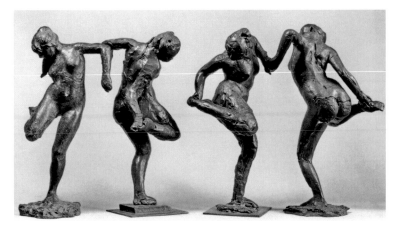

[FIG. 6]
Detail of cat. 23, *Dancer*
Holding Her Right Foot in
Her Right Hand, indicates
wine-bottle cork that the
artist added along the
perimeter of the base
reproduced in the bronze.

discovered in Degas's studio in at least four pieces: head, body, left arm, and left supporting leg, which were subsequently pieced together before casting.[34] If the present sculpture represents Degas's first vision of the dancer that subsequently broke, in his next attempt he made a smaller, more compact figure that is heavily supported by several external armatures—and which did not fall apart. According to Suzanne Lindsay, for a dancer in this position, "the entire body suggests the counterpoised tension of the turned and strained posture."[35] And as in the focal painting of this exhibition, *Dancers at the Barre* (cat. 1), these two sculpted dancers with their forward-looking gaze appear to reach out with their left arms toward a barre for support. Though several drawings of dancers at the barre dating to the same period are known in Degas's oeuvre, only one portrays a similar backward stretch with a raised right foot caught in the hand while the other hand grips the barre.[36]

On the back of the head of *Dancer Holding Her Right Foot in Her Right Hand* is a gap that reveals the distinct cast-in appearance of a square-sided internal armature, plus supplementary wires that must have been removed from the wax before casting. Vestiges of Degas's hand include tool marks seen on the top of the base (fig. 5), the contours of wood bits, and a wine-bottle cork that the artist added along the perimeter of the base (fig. 6)—materials used partly in an attempt to save money on expensive beeswax.

This sculpture displays a stylistic evolution and working pattern analogous to many of the objects in the exhibition. *Dancer Holding Her Right Foot in Her Right Hand* is one of six sculptures in a pose in which the dancer's right leg is bent behind her as she grasps her right foot in her right hand. In four of the figures, all titled *Dancer Looking*

at the Sole of Her Right Foot, the dancer's head is turned to look at her back foot (fig. 7). It is possible that Degas struggled with this pose as he made changes not only to the dancer's position, but also to her body type. Based on the internal and external variations of his original wax sculptures, the series could have been on Degas's mind for well over ten years. One version of the sculpture was cast into plaster during his lifetime and may have been exhibited in a case on the lower floor of his home and studio.[37] In the memoirs of Degas's model Pauline, she noted that she had great difficulty holding this challenging pose for him, and she reminded him that he already had a plaster cast "in the case downstairs," in the same pose.[38] According to National Gallery curator Alison Luchs, this was a pose to which Degas "returned almost obsessively…in sculptured variants…as well as closely related pastels and drawings."[39] In fact, these numerous renditions may relate to Degas's often quoted belief that "one must repeat the same subject ten times, a hundred times" in order to master it.[40] By adding three more sculptures to the set of six, all titled *Dancer Putting on Her Stocking,* an expanded picture of the artist's fascination with this pose becomes more evident as he apparently moved all the way around the figure, capturing the action of a dancer's changing position as she moved her bent right leg from back to front, ultimately holding her foot in both hands.

The artist was influenced by the photographic studies of Eadweard Muybridge, who developed a "stop-action" procedure for photographing sequences of human and animal movement. Degas created sculptures that capture the act of a dancer lifting, holding, and adjusting her right foot. When the full cycle of *Dancer Holding Her Right Foot in Her Right Hand* is viewed in sequence as a complete progression of movement, the series reveals Degas's comprehensive understanding of the human figure in motion and demonstrates the notion of point and counterpoint in sculpture.[41]

1 For example, Royal Cortissoz quotes Joseph Durand-Ruel as having said, "It is quite true that Degas has spent a good deal of time, not only the later years of his life, but for the past fifty years, in modeling in clay. Thus, as far as I can remember—that is to say, perhaps forty years—whenever I called on Degas I was almost as sure to find him modeling in clay as painting…" In Royal Cortissoz, "Degas as He Was Seen by His Model," *New York Tribune*, October 19, 1919, section IV, p. 9.

2 Ambroise Vollard, *Degas (1834-1917)* (Paris: Les Editions G. Crés et Cie., 1924), 112-13.

3 Joris-Karl Huysmans, "L'Exposition des indépendants en 1881," in *L'Art Moderne* (Paris: G. Charpentier, 1883), 226.

4 Plastiline is a name for nondrying modeling clays still in use today. Various spellings and other terms for nondrying clays include plastilin, plasticine, plastilene, plastelina, pâte plastique, plasteïne, and plasteline. See Barbara Berrie, Suzanne Quillen Lomax, and Michael Palmer, "Surface and Form: The Effect of Degas' Sculptural Materials," in Suzanne Glover Lindsay, Daphne S. Barbour, and Shelley G. Sturman, *Edgar Degas Sculpture*, The Collections of the National Gallery of Art Systematic Catalogue (Washington: National Gallery of Art, 2010), 47.

5 Daphne S. Barbour and Shelley G. Sturman, "Degas the Sculptor and His Technique," in Lindsay, Barbour, and Sturman, *Edgar Degas Sculpture*, 35-36.

6 The inventory prepared by Paul Durand-Ruel and Ambroise Vollard between December 1917 and January 1918 was published by Caroline Durand-Ruel Godfroy in Anne Pingeot, *Degas: Sculptures* (Paris: Réunion des musées nationaux, 1991), 192-93.

7 Pingeot, *Degas: Sculptures*, 25.

8 The typescript of the letter from Joseph Durand-Ruel to Royal Cortissoz is now in the Beinecke Library of Yale University. See Charles W. Millard, *The Sculptures of Edgar Degas* (Princeton, NJ: Princeton University Press, 1976), 25-26.

9 Bronze is a misnomer for these sculptures because they are all cast from brass. However, as they are universally referred to as "Degas Bronzes," we will continue to use that term in a nontechnical sense throughout this essay. The three sculptures in this exhibition were analyzed to determine elemental composition of the surface (copper and zinc with some added tin) using x-ray fluorescence spectroscopy (XRF).

10 Degas's brother René and his friend Albert Bartholomé squabbled against the Fevre nephews and Mary Cassatt. Anne Pingeot asserts that the disagreement was not over the principle of whether to cast, but rather how to cast the sculptures. Anne Pingeot, "Degas and His Castings," in Joseph S. Czestochowski and Anne Pingeot, *Degas Sculptures: Catalogue Raisonné of the Bronzes* (Memphis and New York: International Arts and the Torch Press, 2002), 29.

11 The original sculptures were donated by Mr. and Mrs. Paul Mellon to five museums: fifty-two to the National Gallery of Art, Washington; nine to the Virginia Museum of Fine Arts, Richmond, Virginia; five to the Musée d'Orsay, Paris; three to the Fitzwilliam Museum, Cambridge; and one to the Yale University Art Gallery, New Haven, Connecticut.

12 Joseph S. Czestochowski, "Degas's Sculptures Re-examined: The Marketing of a Private Pursuit," in Czestochowski and Pingeot, *Degas Sculptures*, 14.

13 Sara Campbell, "Inventory of Serialized Bronze Casts," in Sara Campbell, Daphne Barbour, Richard Kendall, and Shelley Sturman, *Degas in the Norton Simon Museum* (New Haven, CT: Yale University Press, 2009), Appendix III, 501-2.

14 Suzanne Glover Lindsay, "Degas' Sculpture After His Death," in Lindsay, Barbour, and Sturman, *Edgar Degas Sculpture*, 15-16.

15 Anne Halpern, "Paul Mellon and Degas' Sculptures," in Lindsay, Barbour, and Sturman, *Edgar Degas Sculpture*, 16.

16 Technical Notes:
Provenance: Albino Palazzolo, Paris; Nieson Harris, Northbrook, Illinois' bequest: Private collection, Potomac, Maryland. Campbell in Campbell et al., *Degas in the Norton Simon Museum*, 544.
Marks: Foundry mark: base back proper left corner, side
Estate cachet: base front right corner, right of right foot
Founders initials, AP stamped on underside

17 For a discussion on the identity of the *Little Dancer* see Martine Kahane, "*Little Dancer, Aged Fourteen*—The Model," in Czestochowski and Pingeot, *Degas Sculptures*, 102-5; Richard Kendall, with contributions by Douglas Druick and Arthur Beale, *Degas and the Little Dancer* (Omaha, NE, and New Haven, CT: Joslyn Art Museum and Yale University Press, 1998), 15; George T. M. Shackelford, *Degas: The Dancers* (Washington: National Gallery of Art, Washington, 1984), 69-72.

18 For a discussion of the culture and the young ballerinas refer to Kendall, *Degas and the Little Dancer*, 21-23; Lindsay in Lindsay, Barbour, and Sturman, *Edgar Degas Sculpture*, 127-29; Kahane in Czestochowski and Pingeot, *Degas Sculptures*, 105-6.

19 Lindsay in Lindsay, Barbour, and Sturman, *Edgar Degas Sculpture*, 127.

20 Kendall, *Degas and the Little Dancer*, 38.

21 Kendall, *Degas and the Little Dancer*, cat. 36

22 Sturman and Barbour in Lindsay, Barbour, and Sturman, *Edgar Degas Sculpture*, 116-18.

23 For a discussion of the facture of the original wax *Study in the Nude*, refer to Barbour in Lindsay, Barbour, and Sturman, *Edgar Degas Sculpture*, 144-47, and fig. 2, 146. See also Daphne Barbour, "Degas's Little Dancer: Not Just a Study in the Nude," *Art Journal* 54, no. 2 (Summer 1995): 28-32.

24 Arthur Beale, "*Little Dancer, Aged Fourteen:* The Search for the Lost Modèle," in Kendall, *Degas and the Little Dancer*, 106.

25 Technical Notes:
Provenance: Peridot Gallery, New York; Joseph H. Hirshhorn 1958; Hirshhorn Museum and Sculpture Garden, Washington, D.C., 1966. Campbell in Campbell et al., *Degas in the Norton Simon Museum*, 517.
Marks: Foundry mark: base, behind left foot
Stamped: 19/ F below foundry mark
Estate cachet: base, right side center

26 Millard, *The Sculptures of Edgar Degas*, 69, fig. 98.

27 Degas's early notebooks are riddled with sketches of Greek, Roman, and Renaissance works. See Theodore Reff, *The Notebooks of Edgar Degas*, 2 vols. (Oxford: Clarendon Press, 1976).

28 Jill DeVonyar and Richard Kendall, *Degas and the Dance* (New York: Abrams, 2002), 235.

29 Lindsay in Lindsay, Barbour, and Sturman, *Edgar Degas Sculpture*, 180, notes that this is the only sculpture to be modeled on demi-pointe.

30 The armature on the modèle bronze in the Norton Simon Museum, for example, has a different elemental composition from the sculpture. Barbour in Campbell et al., *Degas in the Norton Simon Museum*, 333.

31 Degas depicted *Horse Trotting, the Feet Not Touching the Ground* off its base, and he would not have been alone in lifting the sculpture of a dancer off its base. See for example Jean-Auguste Barre, *Marie Taglioni in "La Sylphide"* (1837). DeVonyar and Kendall, *Degas and the Dance*, 25, fig 26.

32 Technical Notes:
Provenance: Galerie Alfred Flechtheim, Berlin by 1925. Sold to private collection, Germany. Christie's London, 2 December 1975, unsold. Christie's London, 29 June 1976, unsold. Sale, Sotheby & Co., London, 7 December 1978. Sotheby's, New York, 19 November 1986, private collection, United States. Campbell et al., *Degas in the Norton Simon Museum*, 552.
Marks: Foundry mark base back proper right side
Stamped: 68/ F below foundry mark
Estate cachet: base front proper right side

33 Sturman in Lindsay, Barbour, and Sturman, *Edgar Degas Sculpture*, 246. Sturman in Campbell et al., *Degas in the Norton Simon Museum*, 418–20.

34 The original waxes for the last four numbered sculptures, 69–72, did not survive the casting process and it is presumed that they were the last ones cast and numbered because of their advanced states of disrepair.

35 Lindsay in Lindsay, Barbour, and Sturman, *Edgar Degas Sculpture*, 244.

36 For an image of the charcoal and pastel drawing, *Danseuse à la barre*, present location unknown, see Lindsay in Lindsay, Barbour, and Sturman, *Edgar Degas Sculpture*, 244.

37 Only two sculptures are catalogued as being made from plaster in the inventory made of Degas's studio after his death by Paul Durand-Ruel and Ambroise Vollard in December 1917 and January 1918. (See: Inventory published by Caroline Durand-Ruel Godfroy, "inventaire de la succession," in Pingeot, *Degas: Sculptures*, 192–193). In these two instances, it was the plaster sculpture rather than the extant wax that was photographed for the inventory; however it was the wax that was molded and eventually cast into bronze. See Sturman in Lindsay, Barbour, and Sturman, *Edgar Degas Sculpture*, 229–231. During technical examination of Degas's original sculptures, it was discovered that two other objects were also cast in plaster, *Woman Rubbing Her Back with a Sponge, Torso* and *Head Resting on One Hand, Bust*, but in these two cases no wax original survives.

38 Alice Michel, "Degas et son modèle," *Mercure de France*, February 16, 1919, 457–78, 623–629.

39 Alison Luchs, "The Degas Waxes c. 1878–c. 1911," in *Art for the Nation: Gifts in Honor of the Fiftieth Anniversary of the National Gallery of Art* (Washington: National Gallery of Art, 1991), 204.

40 Marcel Guérin, ed. *Edgar Germain Hilaire Degas: Letters*, trans. Marguerite Kay, (Oxford: Bruno Cassirer, 1947), 119.

41 At the Musée d'Orsay, Paris, this series of sculptures is exhibited in a semicircle epitomizing their related postures and elegantly depicting the sense of movement as the dancer's leg rotates from behind her to directly in front.

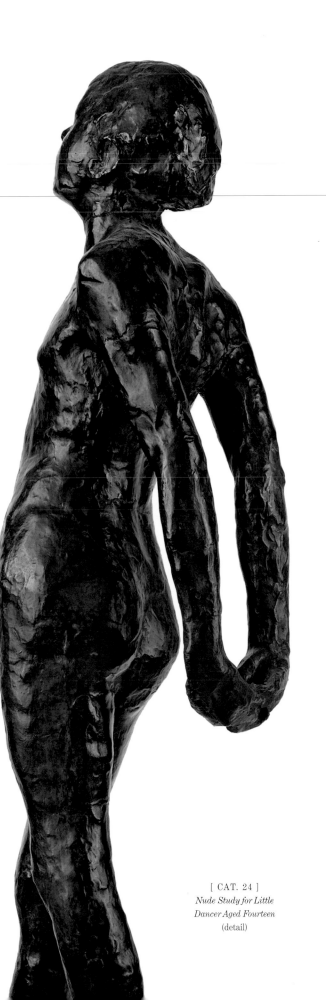

[CAT. 24]
*Nude Study for Little
Dancer Aged Fourteen*
(detail)

AN
INTERVIEW
WITH

BY ROBERT GRESKOVIC

Robert Greskovic
has written on the
subject of dance
since 1972 and covers
ballet for *The Wall
Street Journal.* His
successful *Ballet 101:
The Complete Guide
To Learning and
Loving the Ballet*
(1998), describes how
to observe, interpret,
and appreciate the
dance. He interviewed
Christopherr Wheeldon
on July 9, 2011,
New York, New York.

orn in England in 1973, Christopher Wheeldon
trained at London's Royal Ballet School before
he was accepted to the company at age eighteen.
He was invited to join the New York City Ballet
(NYCB) in 1993 and was promoted to the rank of
soloist in 1998. During his dance career, Wheeldon
worked with famed choreographers, including
Jerome Robbins and George Balanchine, until
2000 when he stopped dancing to focus on chore-
ography. His creative use of classical vocabulary
and his ability to modernize and rework traditional
ballets brings him to the forefront of contemporary
choreographers. Wheeldon was hired by the NYCB
as the company's first resident artist and chore-
ographer. While choreographing ballets for the
NYCB, Wheeldon conceived works for other com-
panies such as the Boston Ballet, the Royal Ballet,
and the San Francisco Ballet. In 2004, the Penn-
sylvania Ballet commissioned him to choreograph
a ballet of his choice. Wheeldon selected, among
his favorites, *Swan Lake,* embracing its coveted
moments, incorporating new performance styles,
and conceiving costumes and sets reminiscent of
the nineteenth century Paris Opera as depicted
by Edgar Degas. He has created more than forty
productions and has become known for bringing a
new perspective to the art of ballet.

[CAT. 14]
The Ballet
(detail)

RG: *When you staged Swan Lake in 2004, you chose a Degas era. Can you tell us what interested you in Degas?*

CW: Two years previously to *Swan Lake*, I'd been to *Degas and the Dance* at the Philadelphia Museum of Art and had been intrigued by many of the backstage paintings and the perspective from the wings looking through the dancers, watching dancers performing on stage, there are these black, tall, top-hatted figures.

RG: *[You mean the sometimes infamous Paris Opera subscribers known as] abonnés?*

CW: The abonnés, yes. This sort of figure intrigued me. He's almost two-dimensional, kind of a cut-out figure and so I researched who these men were and was fascinated because it seemed there was still quite a lot of that going on in the private world of American ballet [today]. But also the power these men had over the young dancers and the parallel between that grasp and the power of Rothbart that he has over the swans. So that's kind of how that started to gestate.

RG: *What was your first exposure to Degas?*

CW: You know, funnily enough, my first exposure to Degas was in the commercial world of Degas, mouse pads, mugs…

RG: *Reproductions?*

CW: Posters, I had a couple Degas posters on my wall as a young dancer growing up. I don't think I saw a Degas painting until I went to the Musée d'Orsay on a school trip when I was eleven. I was already in the Royal Ballet School.

RG: *Was there an art history component at the Royal Ballet School that touched on Degas for you?*

CW: Yes, touched. The dance history classes were excellent at the Royal Ballet School. One of the things that really interested me was that Degas was at the Opera painting the ballerinas around the same time that Tchaikovsky was composing *Swan Lake.* So just the idea of the combination of those two worlds was appealing to me.

RG: *Was there anything about seeing the* Degas and the Dance *show that particularly clicked with you?*

CW: I think what struck me most of all was how accurate all these paintings are in their depiction of the rehearsal process and how things haven't really changed. The outfits have changed… the way that the light comes in through the windows of the studio, that's something that I felt that was very accurate, how I feel when I'm in the room and how the light affects the way that I work, and also just the vividness of the colors in the paintings, the theatricality of them just pulled me in.

RG: *While you were working in Philadelphia, did you find that the dancers for whom you were making the ballet had a familiarity [with Degas]?*

CW: Basically what I did was I took color Xeroxes of every Degas painting that I could find and pasted them up all over the studio, and I encouraged [my dancers] as much as possible to look at the way the dancers are posed, the very naturalistic way. They're dancers, that's what dancers do, you see them sitting around the room in the same poses that you see in these paintings. You put a ballerina today that's wearing a dirty pink leotard in an old practice skirt to rehearse Giselle and she looks exactly like one of the figures in a Degas painting, so even that hasn't changed that much.

RG: *So the show itself is called* Degas's Dancers at the Barre, *which is the name of this picture. What immediately strikes you about this picture of the same name (cat. 1)?*

CW: I think what's interesting about this is the positioning of the dancers, the figure in the background, how overly forced her front leg is on the barre. It's an unnatural amount of turnout that she has and that's exactly what dancers do when they warmup, you know when dancers warm-up, they go to the barre and they force their bodies beyond the positions that they're expected to be in as a dancer in order to push the muscles to a point where they get warm.

RG: *Using the barre for that helps too?*

CW: They'll use all of their body weight, pushing themselves into the barre, in order to manipulate their joints and their muscles. I have this image of dancers in the late 1880s, being physically incapable of doing the sort of things that we do today, but that really wasn't the case (laughs). We've certainly refined a great deal of the classical ballet technique, but bodies were still able to force the turnout.... I think it's interesting that he

chose to take out the [raised] foot [of the dancer in front] (cat. 1 and 2).

RG: *That you just described as being overworked almost.*

CW: It looks actually unnatural, whereas the foot that he includes on the right in the original charcoal sketch is more realistic. She's not quite pointing her toes but she's stretching the arch of her foot. It's quite surreal the way that he's chosen to put in the less natural looking limb.

RG: *How do those proportions strike you compared to a dancer's standard proportions today?*

CW: This girl [in *Dancers at the Barre*] would be considered I think quite zaftig, in a ballet company of today (laughing). I think body types and the expectations of how a dancer should look have changed over the course of more than a hundred years now, but this would not be an acceptable body type for a ballerina of today.... The proportions are good—long legs, shorter torso…and arched foot.

RG: *This is called* Women Combing Their Hair, *not a dance picture, per se (cat. 30).*

CW: No, but you can see he was obviously fascinated by the poses of women preparing themselves in some way for something. You know the opening sequence of *Swan Lake* was a series of tableau of the ballerinas preparing themselves for rehearsal. Dancers, when they perform they snap into that sense of, "I'm on stage so I have to be pulled up."

RG: *Ram-rod straight?*

CW: And look useful and ram-rod straight. If you were preparing to put your hair up, you wouldn't be holding yourself [so vertically]. Your back would be arched, there would be weight in your shoulders, weight in your head. You can see already that sort of composition here…. I think that's what was so shocking and controversial about the Degas paintings. He wasn't painting ballerinas in their finished, theatrical sense. He was painting them in preparation. And often you know the way that the body is stretched, the way that a dancer sits down after a long sequence of choreography and is exhausted is not necessarily particularly lady-like—legs akimbo, open—something that isn't of course shocking to us today, but I'm sure then was.

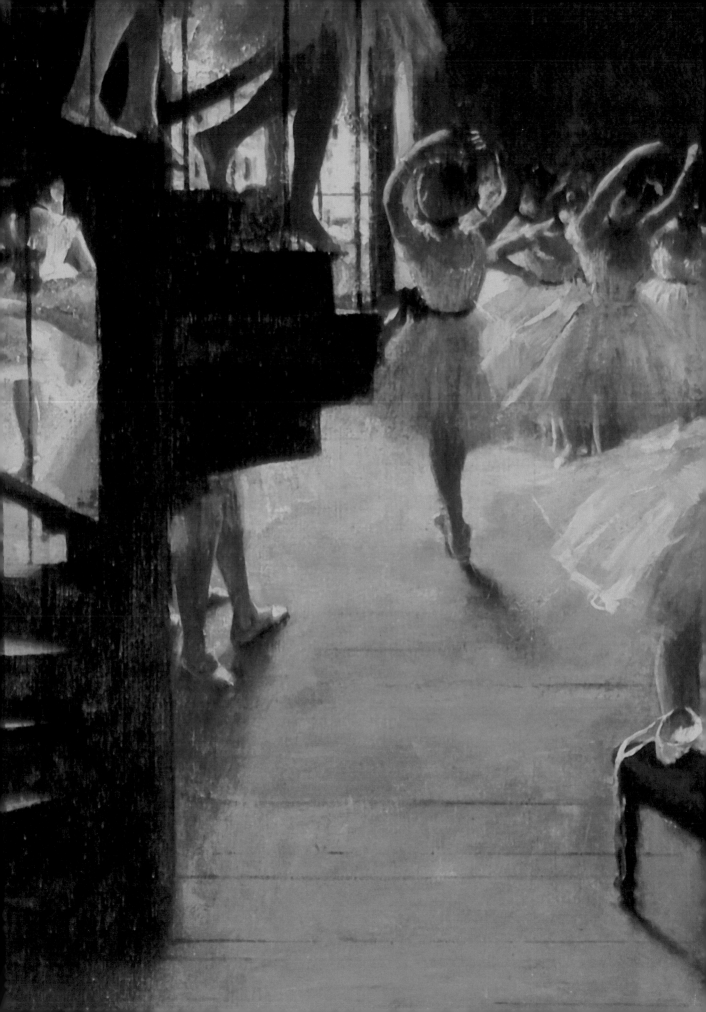

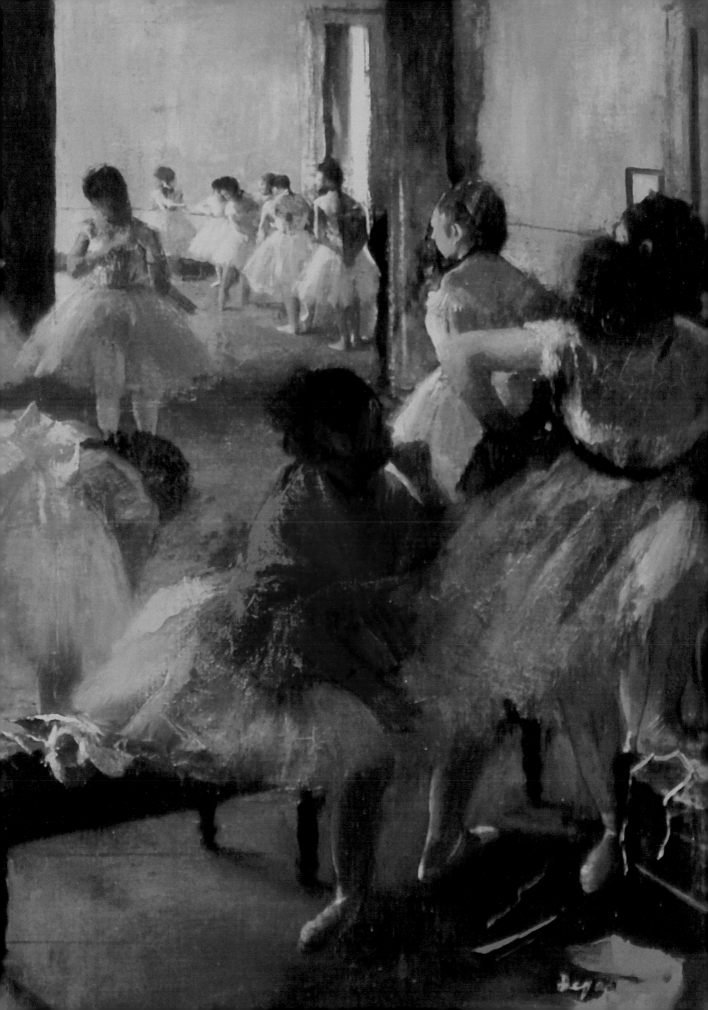

RG: *And now here are some other early pictures. One is called* Two Dancers *(cat. 8).*

CW: Two dancers, yeah, the two women gossiping. On setting up that first scene in *Swan Lake,* set in a ballet studio, very similar to that Degas would have been painting, finding these little moments around the edges that would give a real sense of a rehearsal atmosphere. You've often got a second and a third cast of dancers in the room. They're not getting the attention. So more often than not, they're sitting around talking and they're gossiping about well, "Why is she doing it? You know I could do it a lot better." And I think that's these two ladies having a good gossip about one of their contemporaries.

RG: *So of the other two from this time, the 1870s, one is called* The Dance Class *(cat. 6) and the other is called* Dance Rehearsal *(cat. 5). What see you there?*

CW: I just adore the sense of natural light in these paintings.... At times he painted the light very naturally and at other times he kind of gave the dancers a rather sickly pallor.

RG: *Perhaps the gas light effect?*

CW: But also perhaps reflecting the kind of sweaty, blotchy pallor of the dancers skin after rehearsing you know. I think he was really interested in capturing the way that the dancers were posed, but also the atmosphere, the sweaty smell, of the studio. *The Dance Class* is sort of prettier in a sense because there's more color, he's capturing some of the delicate innocence of the younger dancers and the way that perhaps their chaperones would have made them look pretty in order to be noticed by the ballet master. Whereas this one, *Dance Rehearsal,* is more kind of everyday ballet company at work.

RG: La Petite Danseuse à Quatorze Ans *(Little Dancer Aged Fourteen, fig. 1, p. 76). One question that was actually asked by the curator, curious about your understanding of this, or your view of it, is the position that he has put this dancer in. Is it a working position? Is it a resting position? Is it a fourth? Is it not a fourth?*

CW: It's interesting; it looks much more like a fourth position when the skirt is on.... It also depends very much on which angle you look at it from. If you look at it from [one] angle, it does look much more like a classical ballet fourth position, not particu-

larly turned out, but you know she's fourteen. But, if you look at her [from another angle, by way of] the crossed leg, she looks much more balletic. When you [focus on] her opened leg, it looks far more like she's leaning back on her hip and just kind of relaxing. It depends on which angle you look from; if she was in a fourth position, and it was correct, the head would normally be over the front foot and it's not. Maybe he did intend her to look like she was relaxing. The shoulders are a little round, and she's definitely [keeping her weight] back. Her weight is definitely on her back leg. You can see it several ways, I think. You know she's letting her stomach go. She would have had a sharp whack on the stomach with a stick from her ballet master if she'd been caught doing that...

RG: *In class?*

CW: In class.

RG: *There's been all this study of what Degas meant and did he mean to give his little dancer a bestial look? What do you think of her expressions? Or the look on her face?*

CW: I think it's Degas capturing a moment where she's letting her position go. He's capturing the pose of a little

PREVIOUS PAGE:

[CAT. 6]
The Dance Class
(detail)

girl who perhaps is tired from the end of a long dance class and is gazing off into the distance and not really concentrating on what her teacher is telling her. You know, I think what's sort of fascinating about this [figure] is that Degas obviously was very aware and interested in the moments between the dance, not the dance itself. Many people now continue to share that fascination, I mean, you talk to anybody that gives money to the ballet, or is from outside of the ballet world who appreciates the dance, and how fascinated they are by the everyday, kind of mundane situations. The smell of the room, the corrections, the repetitiveness, the exhaustion—people love to see that. I think Degas is one of the very few artists who has been able to successfully capture that.

RG: Dancer Moving Forward, Arms Raised *(cat. 25). I wonder what the body language of this one says to you, if anything?*

CW: I would say, she must be a modern dancer (laughs) because it's not an accurate balletic pose. She's [posed stretching to the back], her knees aren't straight, and her arms are relaxed. But it's very purposeful, it's very definitely a dance move. You know her weight is over her front leg so there's no question as to whether this is a pose of relaxation and repose or a dance move. That's what I would say about that. But again, you know if he was sculpting a ballet dancer, what he's done is capture the "not quite there moment." You know this could be a movement that hasn't yet completed, so the arms haven't yet achieved the fifth position, the shoulders haven't yet come down and the back knee hasn't straightened. What we also affectionately refer to as *New York Times* dance photography, which is quite often "we're not there yet," so you open the paper and you see yourself in a not-quite-there position. And for a dancer, it's just the worst thing, it's the worst thing, like I said, a position that hasn't [yet been fully] completed.

RG: *Well, this little series here, one is a pastel called* Dancer Adjusting Her Shoe *(cat. 12), the other one is called* Dancers Practicing in the Foyer *(cat. 7), and the other one is called* Ballet Rehearsal *(cat. 9). So what have we here?*

CW: These are all paintings that I looked at for that opening sequence of *Swan Lake* You're walking down a hallway toward the ballet studio and you hear the music in the distance, and there are dancers sitting outside, per- haps on a break. All of these paintings capture so much of that atmosphere, even the smell, even the slightly sweaty smell of the wood floors and the rosin, quite realistic depictions of rehearsal and of a dancer preparing for a rehearsal. She could be fixing her shoe, but she could also be massaging her Achilles. I always looked at this one (cat. 12) and thought maybe she's not fixing her shoe, maybe she's got a sore Achilles tendon, you know dancers are always touching themselves. She to me looks like she's stretching this leg open this way, so she's in more of a stretch position and that she might be in some way kind of working her leg. Or maybe she's just adjusting her shoe (laughing)? . . . When we designed the set for *Swan Lake,* we made a conscious decision to have a painted floor that was painted to look like a Degas wooden floor. Because it's so prominent in all of the paintings, which caused great problems on opening night because they decided to retouch it after the dress rehearsal. The designer didn't like the way it looked and the next day the dancers were on the stage before the performance, slipping and sliding all over the place.

RG: *This is called* Two Dancers Resting *(cat. 19).*

CW: He absolutely nailed the accuracy of the pose of the dancer through the costume, before painting the costume over the top. So it was all about the angle of the body being correct, and where is the weight? If it's shifted over to one side, does that mean that the opposite shoulder is curved? To me it doesn't look like a very restful position. She looks like she's actually working her knee. Or perhaps that's what he means—after she's danced her variations, she's sitting down, and sorting out one of the numerous problems that dancers have physically.

RG: *What you've been saying is that all of this is something you can relate to? Something you've seen?*

CW: Oh yeah, yeah, on a daily basis. May not have been in that costume, but I've sat down in that position at some point.

RG: *And massaged.*

CW: Yeah. I love the French tutu. I think it's the most beautiful tutu in the world. Much more so than the Russian tutu. I find the Russian tutus too big, and too stiff.... When you watch the current productions that are taped by the Paris Opera, there are certain aspects of it that I think are extraordinary. Even dancing a Russian ballet, they have tutus [that] are slightly stiffer, sort of in homage to the Russian style, but they still have that little bit of kind of pillowy softness from the hips, and the way that they're a little bit lower on the hips too. All of those companies have a particular way of making a tutu, and I've always preferred the French tutu.

RG: *And here's one of a dancer, but also a dancer nude (cat. 3) and also at the barre.*

CW: Which is clearly a study for...

RG: Dancers at the Barre.

CW: She's not what we would consider to be a gifted dance physique these days, I mean her knee isn't straight, you would want that knee to be absolutely straight. Today, if [female dancers are] in that position, their upper body from their hips would be absolutely lying flat out across the top of their leg, their head completely down. She's very, I mean this is really breaking it down, but she's rolling forward on her supporting ankle. But having said all of that, she could just be fixing her shoe, in which case, she wouldn't be thinking about doing any of that.

RG: *What say you about this, these dancers in the wings? It's called* Dancers in Green and Yellow *(cat. 21).*

CW: This is a very familiar pose to me and has been captured. There's a Royal Ballet poster, from when I was in the company, which means it must have been in the early '90s, of a very similar composition of ballerinas in the wings, in costumes watching what's going on stage. I think my story here would be that, one of their fellow corps de ballet members has been given the opportunity to dance her first solo variation on stage, and there's always great excitement and a great deal of support amongst the young dancers for their colleagues. So perhaps that's what's going on here, that they've all rushed from their warming positions on the side of the stage, to take a quick peak to see how she does, some probably with support in mind, and others hoping that she's going to roll her ankle and mess it all up so that they get the chance themselves (laughing).

RG: *Called life (laughing).*

CW: Yes, exactly.

[CAT. 8]
Two Dancers
(detail)

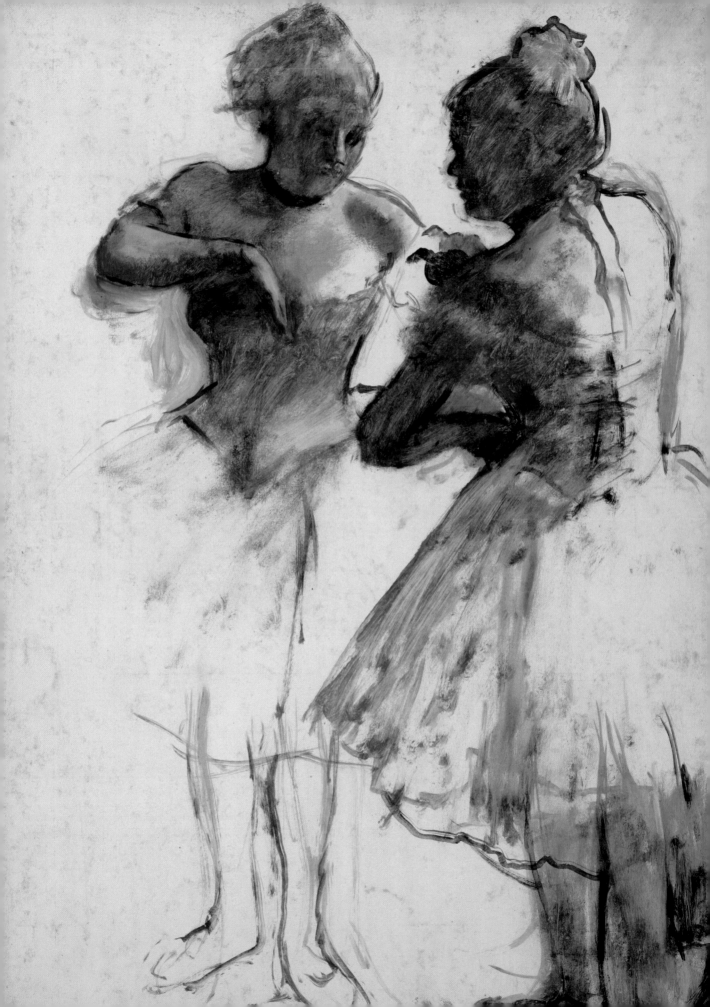

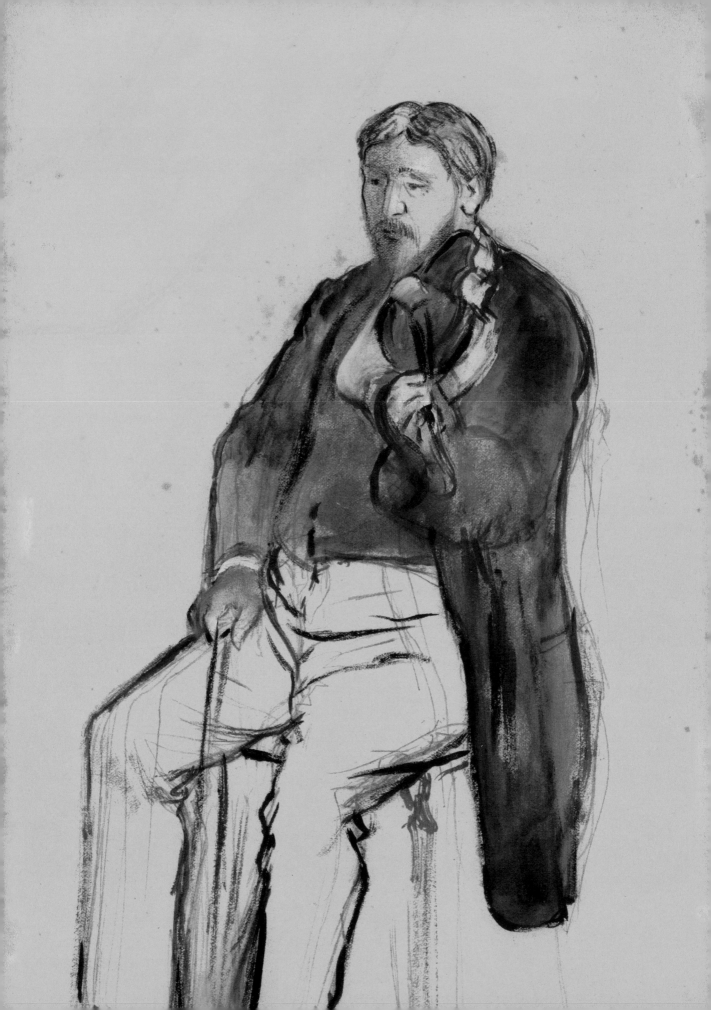

DEGAS IN THE PHILLIPS COLLECTION

ELIZA RATHBONE

Over the course of twenty-one years (1928–49), Duncan Phillips sought out and purchased a total of five works by Edgar Degas. All but the first of these he kept. Although he acquired no sculpture, drawing, or print by the artist, the paintings and one pastel that he did purchase are broadly representative of the artist's work. They span the major decades of Degas's production as well as many principle subjects, from a penetrating study of the human face to a woman combing her hair, from the nude bather emerging from her tub to the dancer and the world of ballet. In recent years, the museum has been given two additional works, a scene of a ballet rehearsal from 1873 (cat. 5) and a study in *essence* of a violin player (cat. 28).

Phillips acquired most of his works by Degas in the 1940s. However, he purchased his first painting by the artist, *Ballet Rehearsal* (c. 1885–91) (cat. 9) from the Durand-Ruel Gallery in 1928. As was often the case, he had the painting sent down to Washington for his approval, and in 1927 proudly included it in an installation, *Acquisitions of the Season* of 1926–27. While other works by Honoré Daumier and Vincent van Gogh featured at that time did not remain in his collection, the work by Degas became a favorite. The importance Phillips attached to this work is evident from its frequent inclusion in gallery hangings during the late 1920s and throughout the 1930s and '40s. It hung for many months at a time almost every year in the '30s.[1] During the '40s, the painting returned to the music room of The Phillips Collection where it sometimes remained on view for years at a time. There it would hang primarily with works by Daumier as well as James McNeill Whistler, Giorgione, and other works by Degas.[2]

Phillips clearly made a connection between the work of Degas and modernism, as his collection included many artists who admired Degas—Pierre Bonnard, William Merritt Chase, Henri Matisse, Pablo Picasso, Walter Richard Sickert, John Sloan, and Edouard Vuillard. The painting was among the treasured few that were sent to Colorado for

[CAT. 28]
Study of a Violin Player
(detail)
1863
Oil (*essence*) on paper
14 1/8 x 20 1/2 in.

safe storage in 1942 during World War II. In 1952, in honor of Yale University's 250th anniversary and the founding of a new wing for the Art Gallery and Design Center, Phillips made the decision to part with this much-loved work, stating that it was "greatly needed at Yale" and making what he felt was "an important contribution."

The earliest work by Degas that Phillips purchased is *Melancholy* (cat. 29). In 1941, at Bignou Gallery, New York, Phillips first saw this exceptional work, a small painting of only seven by nine inches. It has the dimensions and deft handling of a study but the command of a complete and unique work of art. A young woman leans forward against the back of a chair, her arms folded across her chest, her face in profile, looking down at what may be a fire glowing beyond the confines of the picture itself. This tender and sympathetic portrait definitively puts to rest any questions raised of Degas's so-called misogyny. The woman in this little painting, which gains intensity by its very size, has never been identified with certainty. However, a contemporaneous portrait of a favorite model, Emma Dobigny, makes her a possible sitter.[3] Painted in the late 1860s, Degas is already defining himself as an artist of private moments and psychological intensity. Lost in thought, her pose and gesture suggest that she is unaware of any viewer. It is a painting of undisturbed inner concentration to which every detail contributes. With its rich, subdued, warm palette, offset by the light on her face, her white collar and the light coming from the background as if from a window, Degas adumbrates the range of effects of indoor light he would explore during the next decade.

One year earlier at the Carroll Carstairs Gallery in New York, Phillips also acquired a small work in oil on paper from the 1870s most commonly known as *Women Combing Their Hair* (c. 1875–76) (cat. 30). In this piece, which shows three views of a girl combing her long tresses, Degas offers three distinct variants of the figure, standing and combing her hair down the right side of her body; seated on a folding chair with her hair thrown over her head, bending forward to comb it down in front of her; and seated on the ground and combing it over to the left side of her head. Were the figures not situated in a setting suggesting an outdoor landscape, we might imagine them as three views of a woman moving around her dressing room as she tends to the daily routine of combing out her tresses, barefoot and dressed only in a chemise. Presumably the landscape is pure invention, perhaps designed to unite the figures in one time and space. In the late 1870s, Degas would

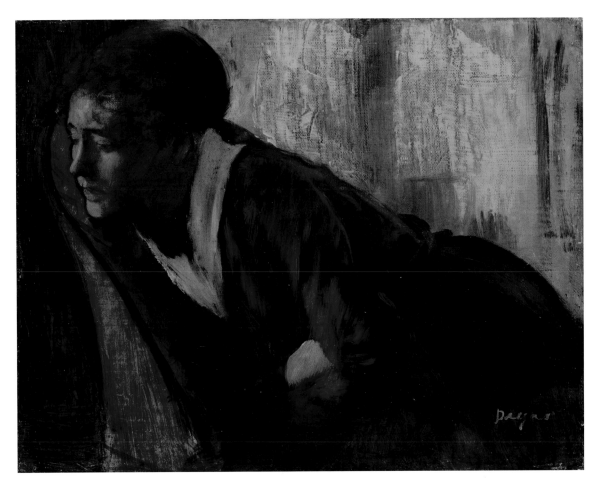

[CAT. 29]
Melancholy
Late 1860s
Oil on canvas
$7\,^{1}/_{2}$ x $9\,^{3}/_{4}$ in.

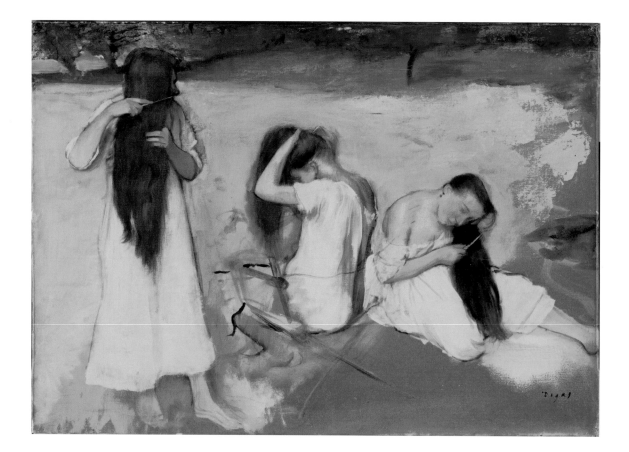

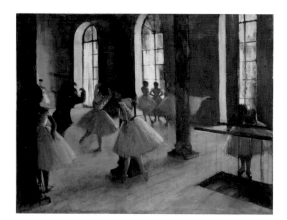

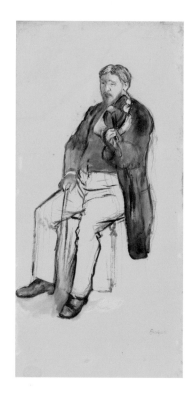

combine three views of the same figure on a single sheet on numerous occasions, most notably, for example, in studies of Marie van Goethem for *Little Dancer Aged Fourteen,* both clothed and nude. All of these drawings suggest movement around the model and the model's three-dimensionality. Degas would continue to pursue the subject of a woman combing her hair throughout his life. During the 1880s he depicted her in the nude, revisiting a range of positions and attitudes that he had begun to explore in his seminal work of the mid-1870s. Sometimes another figure of a maid tends the hair of the model while she, with her hands on her hips, holds herself steady and resists the pull of the comb. Phillips appreciated Degas's fusion of influences, including Japanese prints showing scenes of women in private pursuits.

With the purchase of *Dance Rehearsal* in the '20s and these two small works acquired in the early '40s, Phillips had begun to represent key themes from Degas's work in his collection. He appreciated the artist's sources in works from antiquity and the Renaissance, and Degas's sense of the timeless universality of specific attitudes and positions assumed by the human body. At the same time, Degas extended and expanded that repertoire, vast as it was, to poses not yet heard of or imagined in his exhaustive pursuit of a seemingly infinite vocabulary of movements. His unending research into female anatomy and the poses assumed in the course of quotidian activities is evidenced in his continual study in drawings and sculpture of the living nude model.

Having chosen key works by Degas from his early and middle years, Phillips pursued large-scale late works by Degas in 1944 and 1949, and purchased *Dancers at the Barre* and *After the Bath.* Both works were sold from the artist's studio after he died, and both passed through the hands of the principle dealer of Degas's last years, Ambroise Vollard. In the space of only five years, Phillips identified and acquired in these two works masterpieces that express the extraordinary achievement of Degas's late years. While most of Degas's dancers are not portraits of specific individuals, it may be that in *Dancers at the Barre* there is an identifiable model for the figures. A portrait contemporaneous with the first versions of the painting has been identified as depicting Josephine Chabot; indeed her portrait of 1884 resembles the figure depicted in several studies for the painting.[4] Degas's apparent fascination with her may have contributed to the numerous related studies he made in preparation for his ambitious painting. Bathers and dancers, subjects that sustained Degas's attention for decades, are summed up

and epitomized in these late masterworks that reveal the power, fervor, and mastery of the artist. Typically Degas's bather is in the process of getting out of her tub. In the pastel *After the Bath,* he creates graceful form and sinuous contours from the awkwardness of a woman poised on one foot while lifting the other over the high rim of her tub. Starting with her left hand, the movement of her body ripples through to her elevated right foot. She leans firmly on her strong left leg at the center of the composition, which, like a pillar, supports the entire extension of her body. It is a study in momentary equilibrium. Degas's bather closely resembles the figure in his sculpture *Dancer Holding Her Right Foot in Her Right Hand* (cat. 23), in which we find nearly indistinguishable these figures of bathers and ballet dancers, each captured in a moment between balance and instability. *Dancers at the Barre* also takes as its subject a daily exercise dependent on strength and balance.

Given the primacy of pastel as a medium in Degas's late years, *After the Bath* was a superb and indispensable acquisition for a collection intended to represent the salient aspects of the artist's subject matter and technique through a handful of key works. At the same time, pastel, Degas's favorite medium in his last years, had a marked influence on his execution of *Dancers at the Barre,* which Phillips described as "a thrilling vision of dynamic forms in space." In both works, the hand of the artist is present everywhere, both as draftsman and colorist but above all as a tireless investigator of life, movement, and the human condition. As Edmond de Goncourt said of Degas in 1877, "He seems to have a very restless mind." In two masterstrokes, Phillips perfectly completed his unit of works by Degas.

[FIG. 1]
After the Bath
c. 1895
Pastel on paper
30 ½ x 33 ⅛ in.

[1] Hanging records show that the work was on view for several months in 1931, 1932, 1934, 1935, 1936, 1937, 1938, 1939, and 1941. Starting again in 1944, it remained on view in the entrance hall for four and a half months while the works of art around it changed.

[2] See The Phillips Collection installation records.

[3] Theodore Reff, "The Pictures within Degas's Pictures," *Metropolitan Museum Journal* 1 (1968): 147.

[4] Richard Kendall and Jill DeVonyar have identified the sitter formerly called Mademoiselle Sallandry. See *Impressionist and Modern Art Evening Sale,* Sotheby's, London, June 22, 2010, Lot. 35.

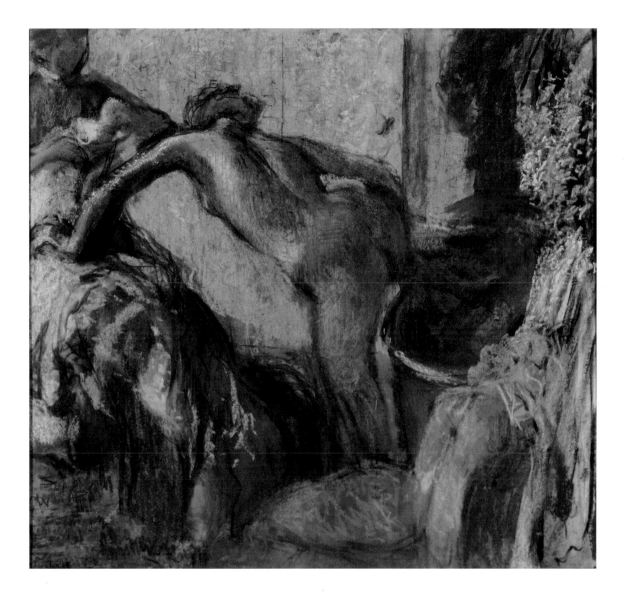

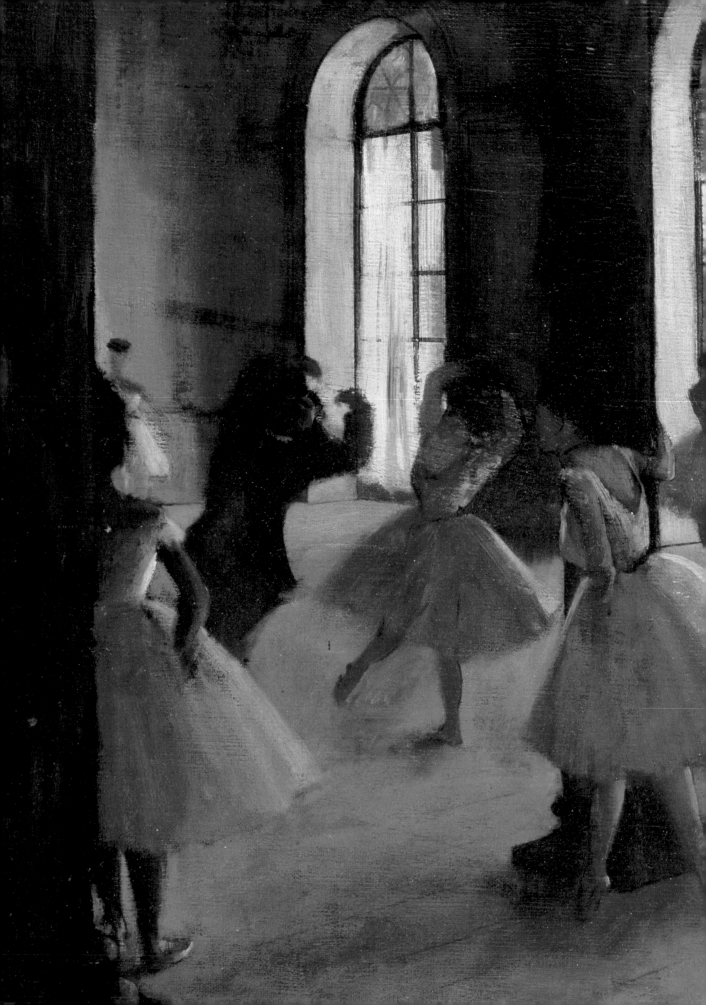

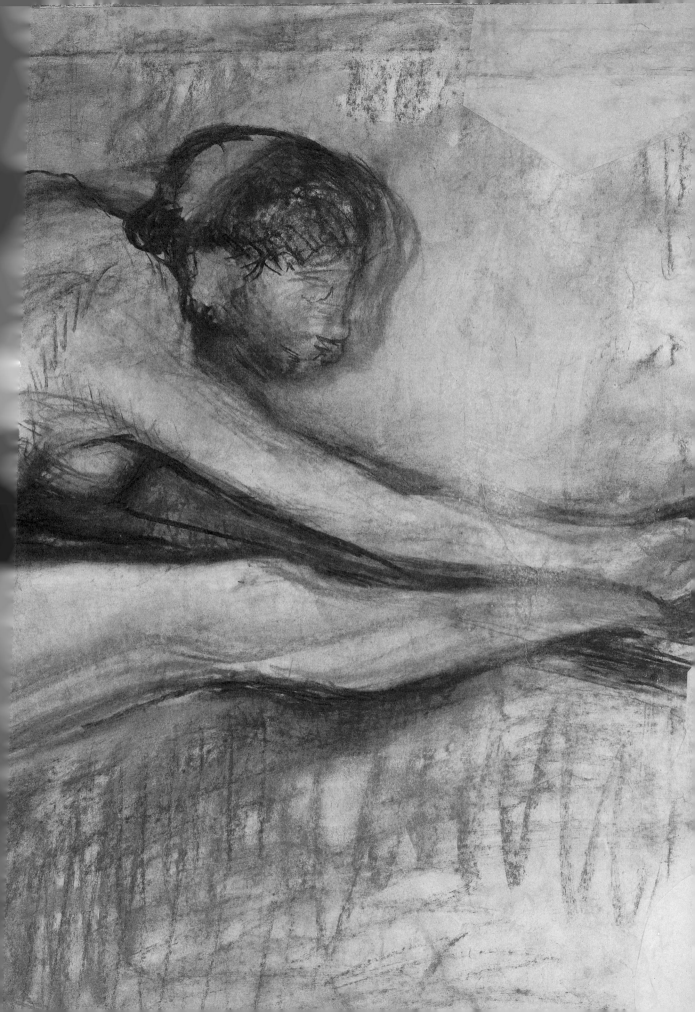

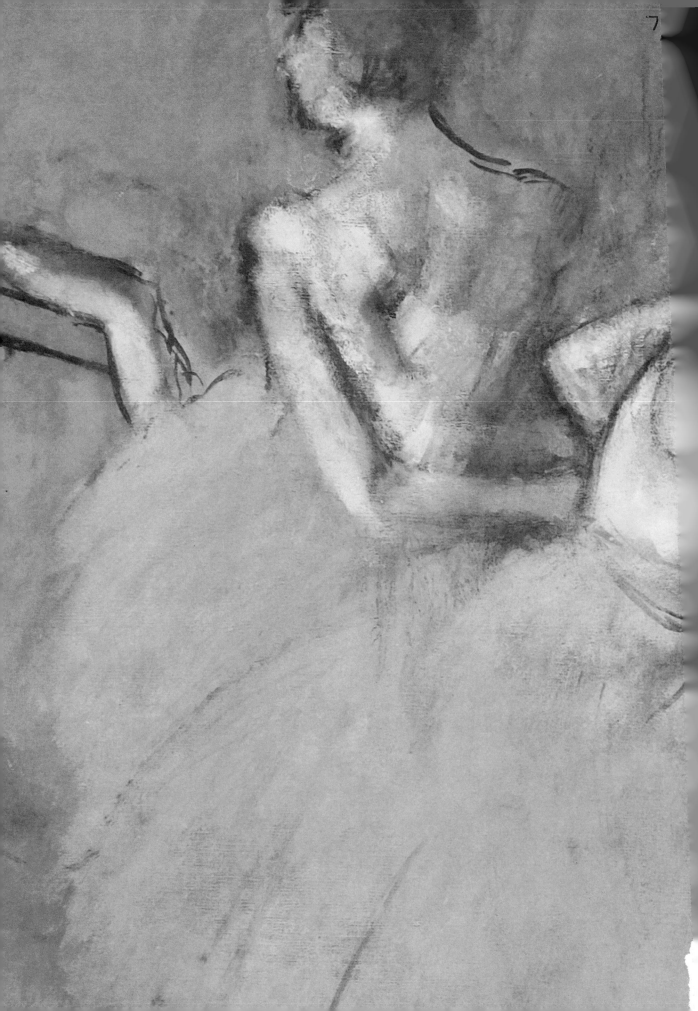